MONTROSE
THROUGH TIME
Tom Valentine

AMBERLEY PUBLISHING

First published 2011

Amberley Publishing Plc
The Hill, Stroud
Gloucestershire, GL5 4ER

www.amberley-books.com

Copyright © Tom Valentine, 2011

The right of Tom Valentine to be identified as the
Author of this work has been asserted in accordance
with the Copyrights, Designs and Patents Act 1988.

ISBN 978 1 84868 615 1

British Library Cataloguing in Publication Data.
A catalogue record for this book is available from
the British Library.

Typeset in 9.5pt on 12pt Celeste.
Typesetting by Amberley Publishing.
Printed in the UK.

Introduction

Montrose derives its name from its position on the coast of Angus, occupying the flat promontory formed by the waters of the North Sea, the River South Esk and the tidal basin which is the largest salt water basin in the UK. It lies about midway between Aberdeen and Dundee. The ancient name of Montrose was Celurca.

One thing will always remain from memories of Montrose – it is a beautiful place. Its motto perhaps is the most beautiful of all the civic devices of Britain: *mare didat, rosa decorat* – 'the sea enriches and the rose adorns', a phrase both poetic and truthful. The town itself has earned the title of the handsomest town in Angus, which is surely a modest claim, for more than one visitor has, discounting the disparity in size, found difficulty in deciding which of the trio, Aberdeen, Edinburgh or the Venice of Scotland, should be given pride of place as Scotland's most beautiful town. Wherever possible, open spaces have been transformed into public parks and gardens. Many of the streets are broad and tree-lined, and remind one of the Parisian boulevards in their general aspect. The skyline is dominated by Gillespie Graham's steeple, 2,010 feet high, which is a conspicuous landmark for miles around, while the public buildings of the town, distinguished and impressive as they are, are matched in elegance by the taste shown in private building enterprise. The core of the town is its High Street, which is the widest one in Scotland, aligned north–south and home to most of its shops as well as to a collection of its fine buildings like the library, the Town House, and Montrose Old Church. The High Street has picturesque closes that lead to secluded gardens, and those closes were used by smugglers in years gone by. To the west of the High Street is the main railway north to Aberdeen and south to Edinburgh and beyond. Farther west is Montrose's tidal basin. East of the High Street is an interesting area characterised by open spaces, the Mid Links, in which you find bowling clubs, and the town's football and cricket grounds. East again and you come to the open, largely grassy areas lying behind the dunes, which in turn lie behind Montrose beach. Here is the town's camping and caravanning site, the golf courses, and a range of attractions such as the Trail Pavilion that bring a genuine seaside resort feel to this part of the town. To the south, on the banks of the River South Esk, is where Montrose's busy harbour is found, which has steadily grown over the past 900 years with its Sea Oil Base which was built in the 1970s. As a holiday resort, Montrose has many attractions to offer such as excellent golf, extensive links and can boast the best sandy beach on the east coast of Scotland. Famous people with notable connections include James Graham, 1st Marquess

of Montrose, a Scottish nobleman and soldier born in Montrose in 1612. Joseph Hume, a Scottish doctor and politician, was born in Montrose in 1777. Violet Jacob (1863–1946) was a Scottish writer, now known especially for her historical novel *Flemington* and her poetry. Andrew Melville, a radical Presbyterian who ensured the completion of Knox's Reformation in Scotland. Moving out of town, one mile to the south lies the old fishing village of Ferryden, where there was once 160 fishing boats and 350 fishermen, and an equal number of fisherwomen. A further mile is the old, small fishing village of Usan, where the main row of houses now lie empty and in ruins. Usan is first recorded in 1548, but possibly existed earlier. Moving to the north one mile takes you to the village of Hillside, where Sunnyside Royal Hospital is situated, and a further two miles you will find the village of Craigo, where a thriving mill once operated.

My interest in vintage postcards began in the early 1970s. While on holiday in London, I visited a stamp fair at the Café Royal, Regent Street, and found that some of the dealers were selling old postcards. I started looking through the Scottish boxes; they were not sorted into counties, so I had to look through them all to find Montrose ones. I soon found my first one, which was of Rossie Castle on the outskirts of Montrose. This castle had lain in ruins for many years before the army destroyed it in 1957. I always remember that what caught my eye on finding this card was that the postmark was on the picture side of the card. I found a few more after that, including some Ferryden ones. I was then hooked on this new hobby and never looked back. My full collecting areas are now the Scottish county of Angus, Libya and Malta, lighthouses and Scottish village churches. Postal history (collecting postmarks on letters and cards) is also another theme I collect, specialising in the county of Angus and various other places and countries. My original hobby of stamp collecting is now third on my list!

Tom Valentine

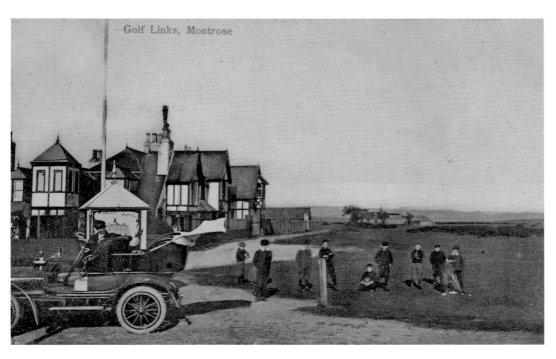

Golf Links, Montrose

Montrose Medal Golf Course
Montrose has the fifth oldest golf course in the world; this shows the first tee at Montrose Medal Golf Course, with Grey Harlings house to the left.

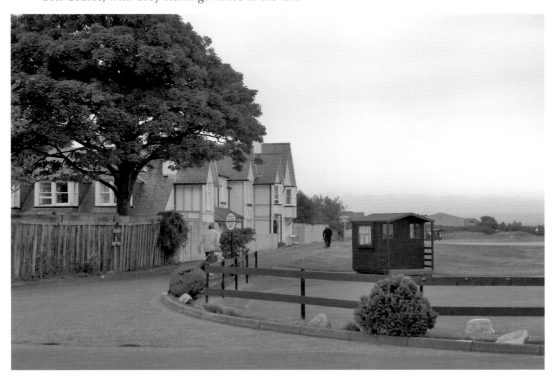

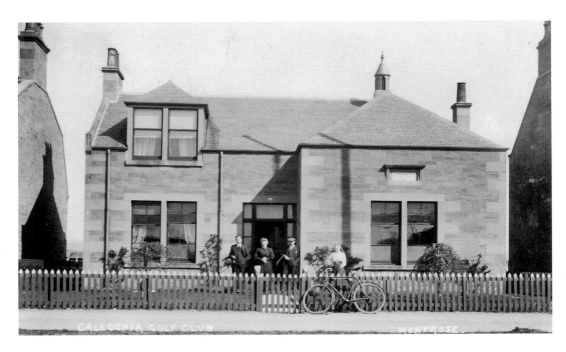

Caledonia Golf Club

The Caledonia, which was instituted in 1876, had its clubhouse erected in 1901. It moved from Dorward Road to the converted Pierrots' Pavilion on Trail Drive in 1975, next to the former premises of Winton's, the golf club manufacturers. The original clubhouse is now a private dwelling.

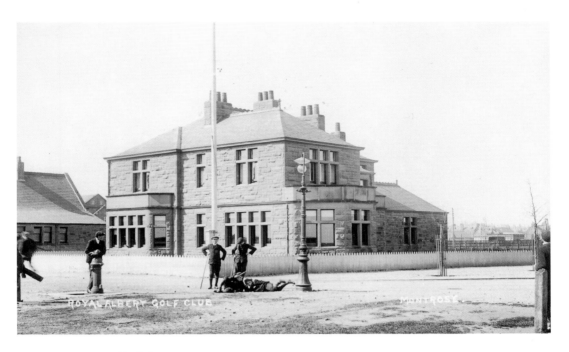

Montrose Golf Club

Montrose Golf Club was formed in 1810, and this became the Royal Albert Golf Club in 1845. In 1986 it came known as the Royal Montrose Golf Club, after amalgamating with the Victoria Golf Club and the North Links Ladies Golf Club. They celebrated their bicentenary in 2010.

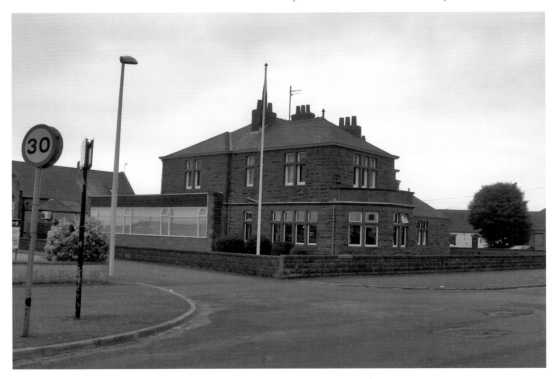

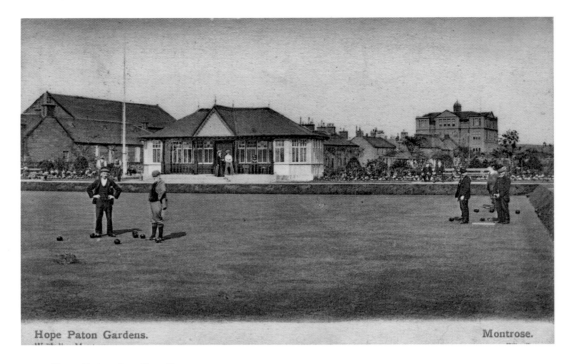

Hope Paton Gardens. Montrose.

Hope Paton Bowling Green

The Hope Paton bowling green was opened in 1904. A new clubhouse was built next to the old one and was completed between 1989 and 1991. The now-demolished North Links School can be seen in the background.

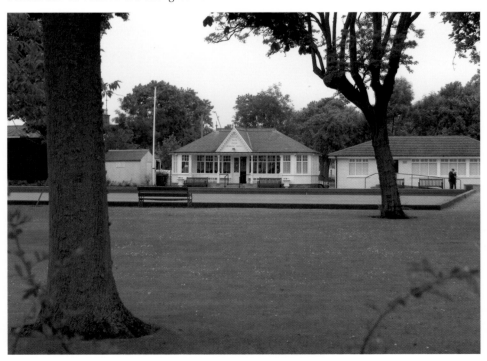

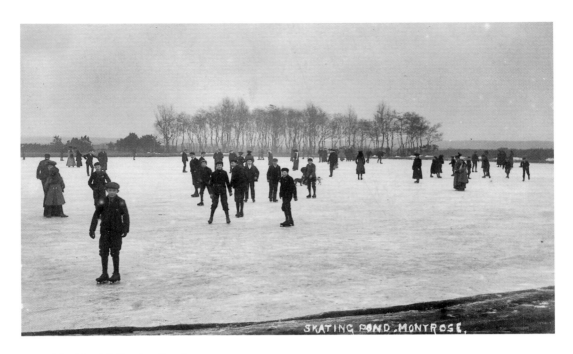

The 'Curly' Skating Pond

This image shows the skating pond, now known as the 'Curly', where many a youngster spent their summer days sailing their model boats and catching tadpoles in jam jars. It was still a popular place for family picnics around the pond where the swans, if around, would be fed.

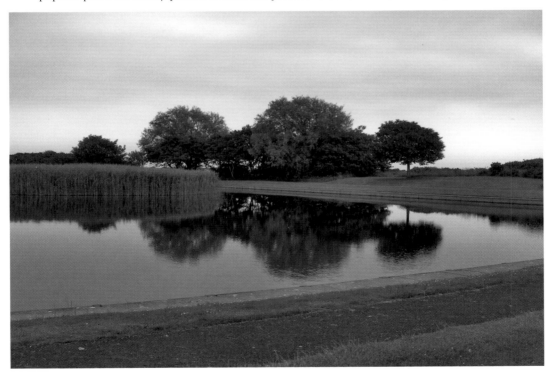

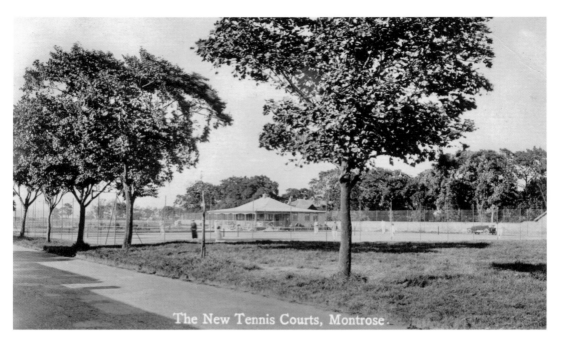

The New Tennis Courts, Montrose.

The Tennis Courts

The new tennis courts situated between Warrack Terrace and Dorward Place moved from the links after it closed in 1932. Many a tennis tournament has been played here in the summer months.

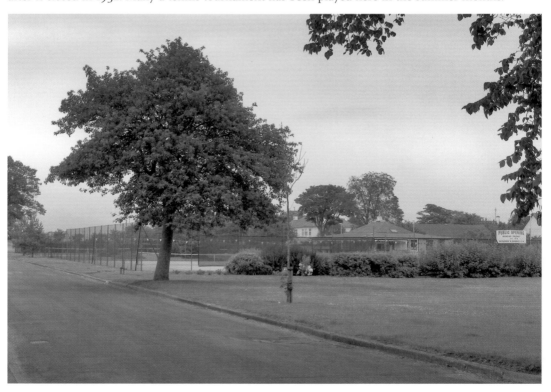

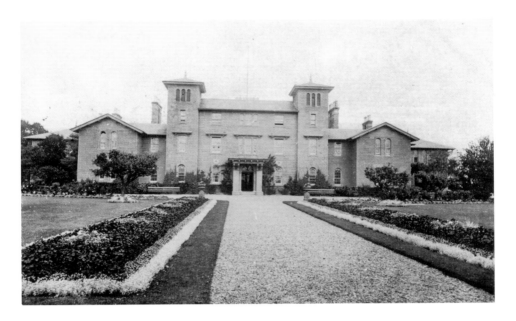

Dorward House

Dorward House care home is near the top of Dorward Road, and was originally a House of Refuge. William Dorward built and gifted this building to the town. The foundation stone was laid in 1838 and the opening took place on 29 June 1839. Under Dorward's will, his House of Refuge would only admit those adults and children whose names were firmly on the Pauper's Roll for Montrose and Ferryden, and who were recommended to Dorward House by the inspector of the poor.

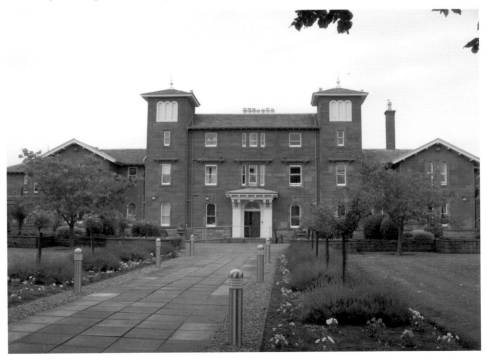

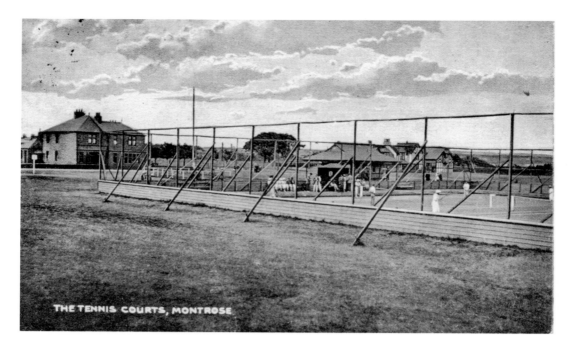

THE TENNIS COURTS, MONTROSE

The Links

The original tennis courts were situated on the links. They were opened in 1912 and closed in 1932. This ground is now used yearly for the Montrose Highland Games. The golf shop behind it has since been extended.

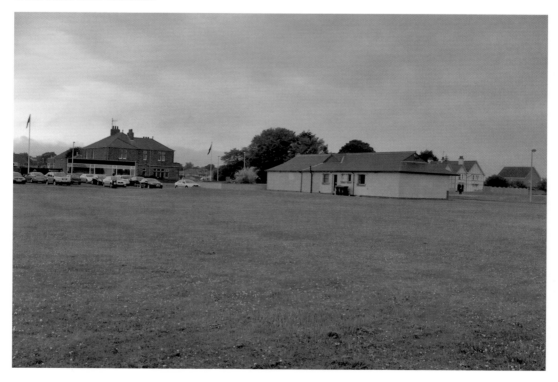

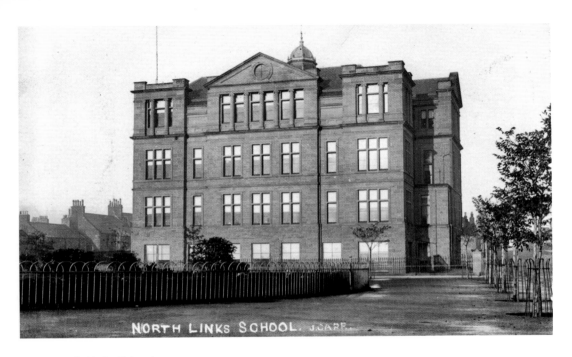

North Links School

The North Links School was in White's Place, and opened in 1897 at a cost of £18,000, serving the children in the north end of the town. It was one of the few primary schools that had a swimming pool, which was below the ground floor, next to the gym hall. It was demolished in the early 1980s and sheltered housing now stands in its place.

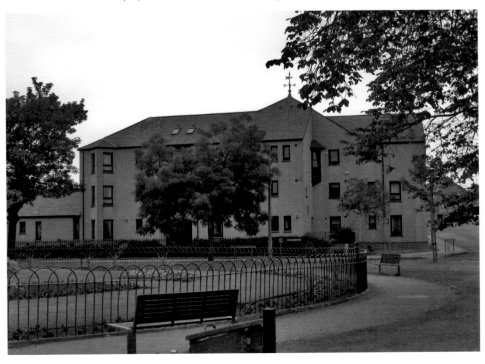

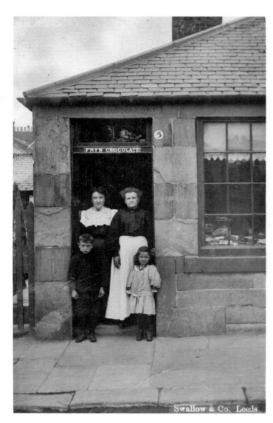

The School Shop
The North Links School 'shoppie' was to the left of the school, and this is where the children spent their pocket money at school break time. This shop is now a canine beautician business.

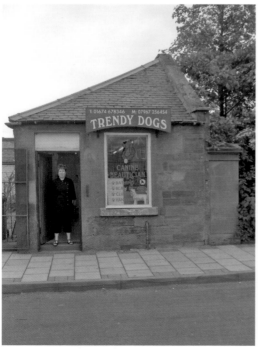

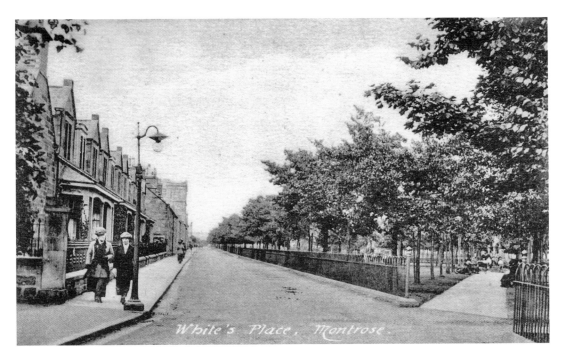

White's Place

Little has changed here in this view of White's Place, with the entrance on the right to the Jamieson Paton Park and fountain. White's Place ran from Provost Scott Road to Dorward Place.

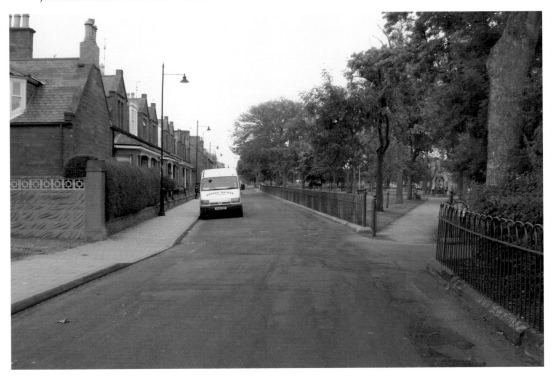

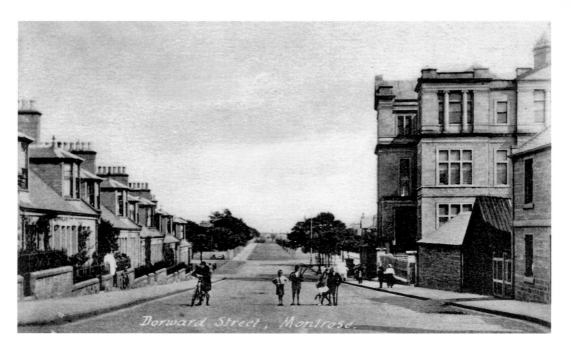

Dorward Street

Dorward Street took you from the bottom of North Street to Dorward Road, which in turn led to the golf course and beach. The sheltered housing which replaced North Links School can be seen to the right.

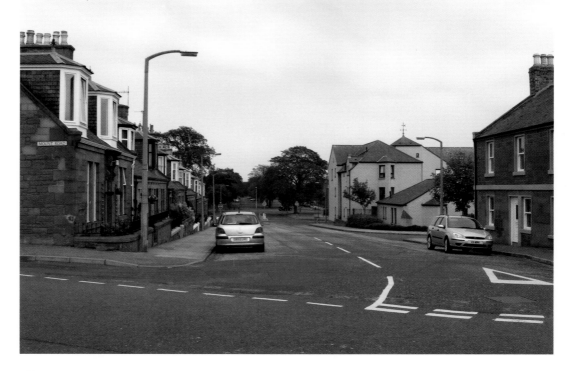

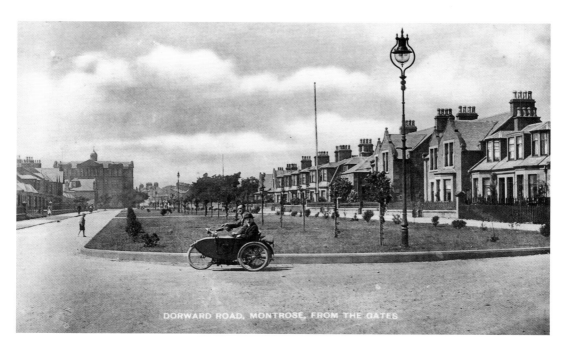

DORWARD ROAD, MONTROSE, FROM THE GATES

Dorward Road

A view from the bottom of Dorward Road looking west before entering the Trail Drive, on the way to the golf and beach areas. The trees in the centre of the grassy area are now well grown, and the Caledonia Golf clubhouse is the building on the right with the flag pole.

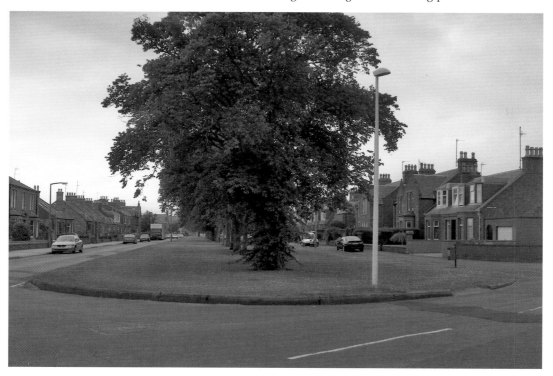

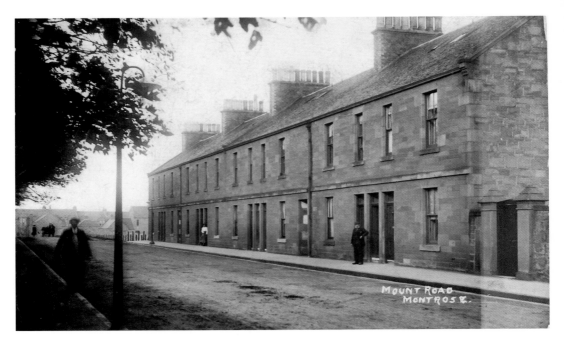

Mount Road
Little change here in this back street view of Mount Road, which joined Mill Street and Rosehill. Council housing has been built to the left of the nearby street lamp standards.

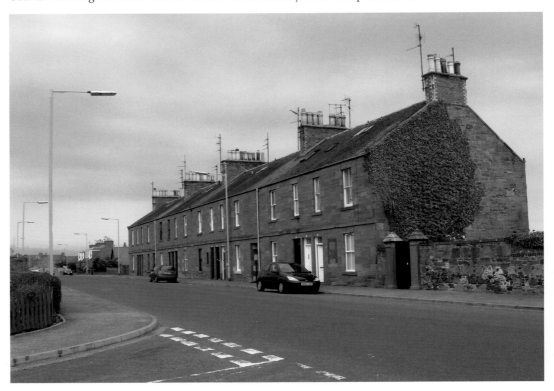

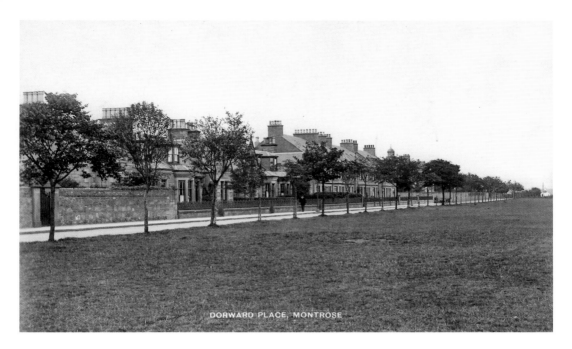

DORWARD PLACE, MONTROSE

Dorward Place

Dorward Place joins White's Place to the end of Whinfield Road and shows it before the tennis courts moved from the links. The houses have not changed and still have their very nice character. The 'Curly' pond is at the end of this road.

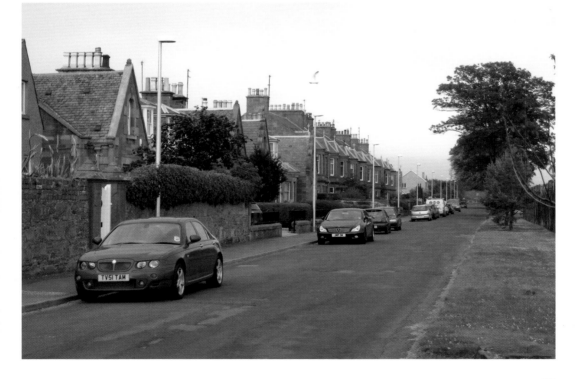

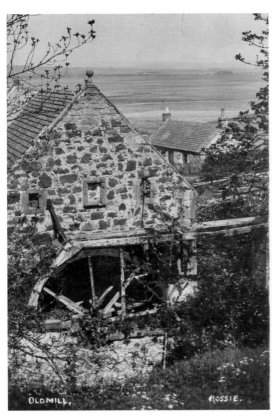

Rossie Mills
The old mill was situated in between the Forfar and Arbroath road junction, on the south side of the town. Demolished many years ago, private housing now occupies the site of the mill. The area is called 'Rossie Mills'.

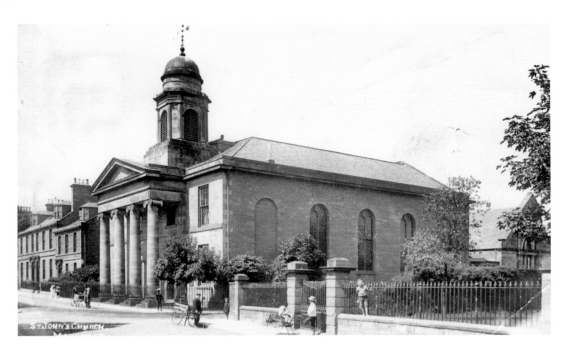

St John's Church

St John's church is to be found in John Street at the Mill Street junction. It has not been a place of worship for many years and was last occupied by the *Montrose Review* press, and now presently lies unoccupied. Little has changed to the outside apart from the metal railings at the front, which were probably taken away during the Second World War.

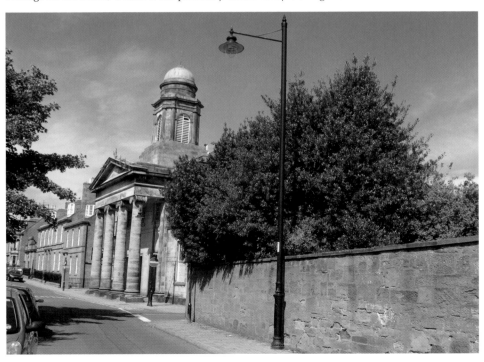

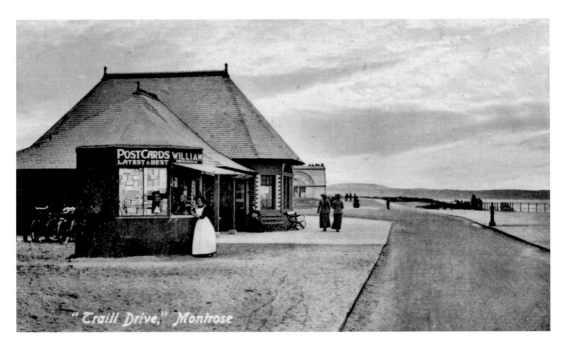

Trail Drive

Trail Drive at the beach front, showing the beach café and the Trail Pavilion. This area has all been modernised in recent years, but the main two buildings keep their originality. The Trail Drive was opened in 1912.

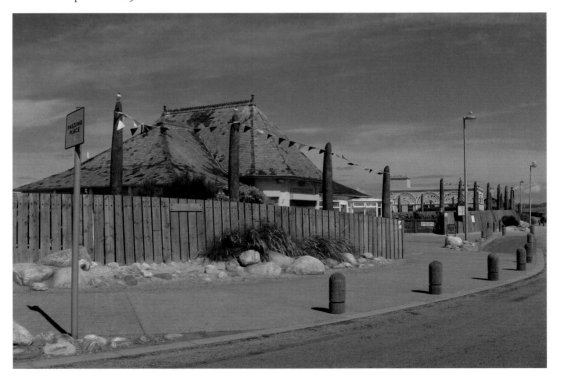

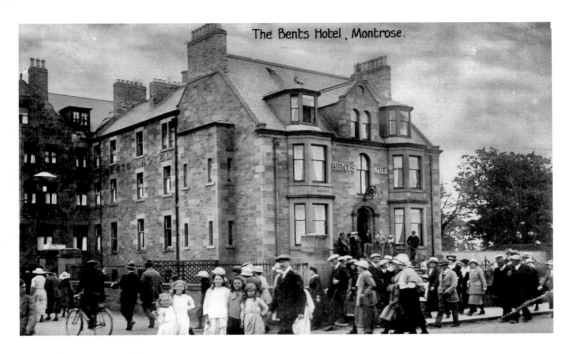

The Bents Hotel, Montrose.

The Bents Hotel

The Bents Hotel was built at the beginning of the twentieth century, facing the old golf course, before it was moved northwards. It is situated at the bottom of Bent's Road, and has now been converted to private flats and is called Marine House.

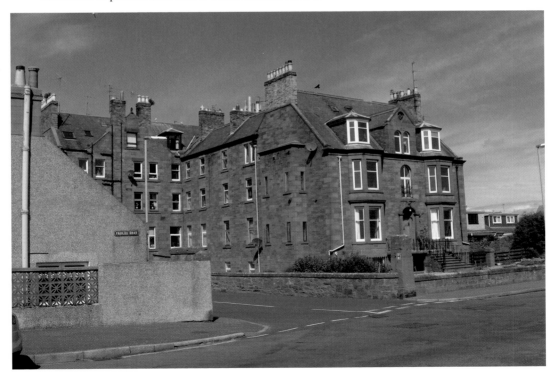

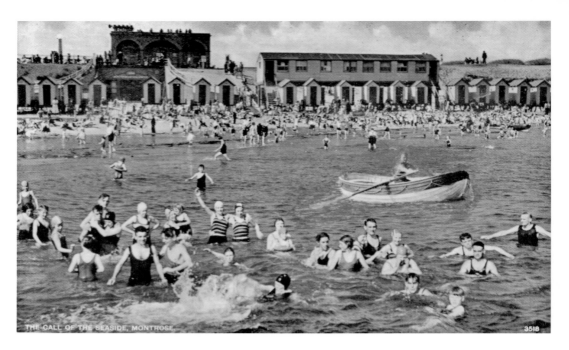

Montrose Beach

View of Montrose beach looking up to the pavilion. Montrose beach, with its 3 miles of golden sands, is now easily accessed by steps and a boardwalk. Over the years, this beach has fallen victim to coastal erosion and work has been carried out to help prevent this.

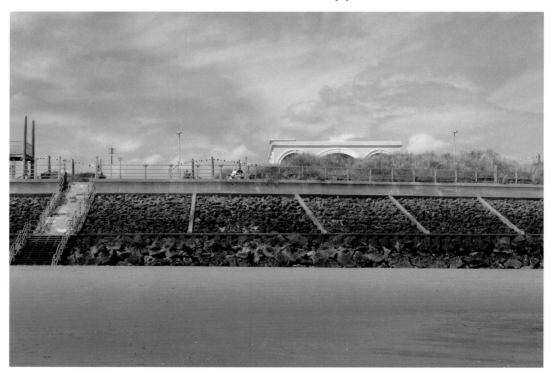

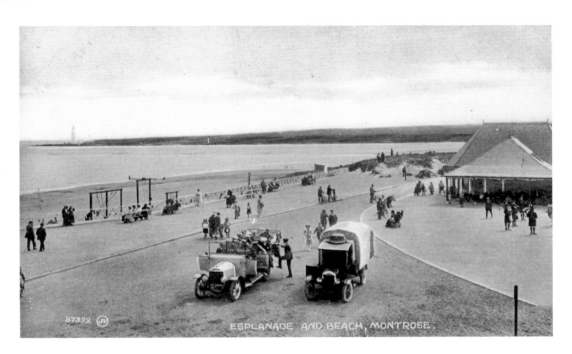

The Esplanade

This image looks south from the esplanade and beach, showing the improvements that have been recently completed. This includes car parking facilities and a sea-viewing stand. Popular with holiday-makers, local people come here for their lunch breaks too.

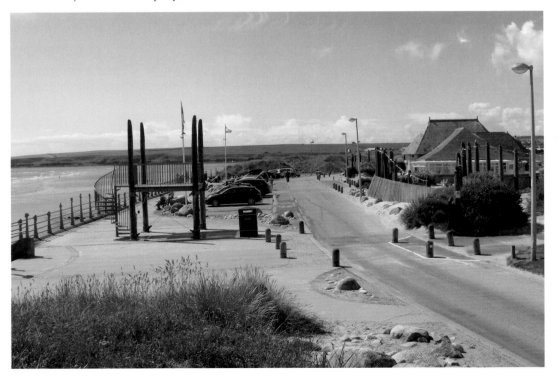

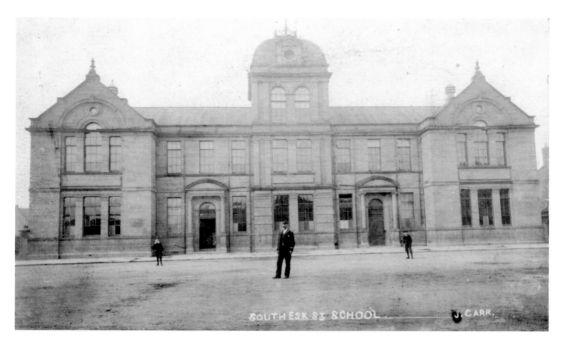

Southesk Primary School
The Southesk Primary School served the children on the south side of Montrose. It was opened in 1891 at a cost of £6,400. Little has changed at the front of this school.

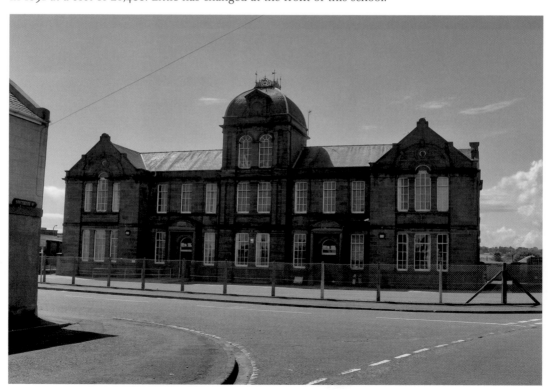

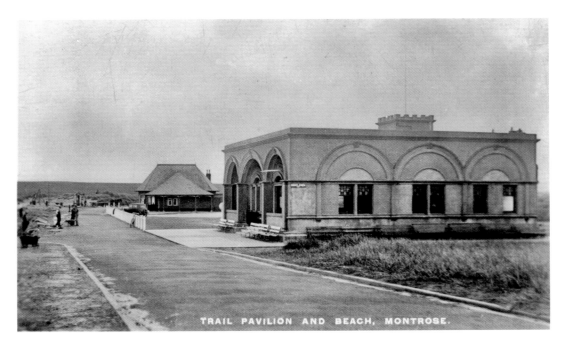

TRAIL PAVILION AND BEACH, MONTROSE.

The Trail Pavilion
The Trail Pavilion on the beach front has recently been modernised, but it still keeps its original look and is a good place to retreat when the weather gets too much for the holiday makers. The beach café can be seen in the background.

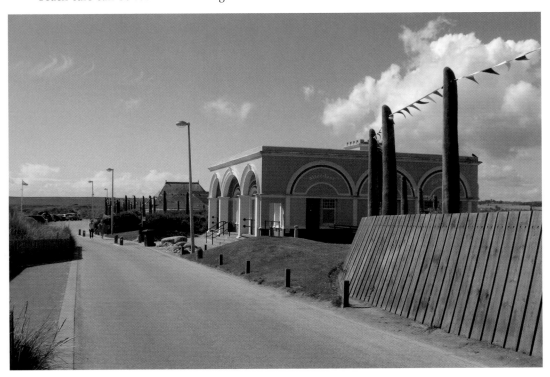

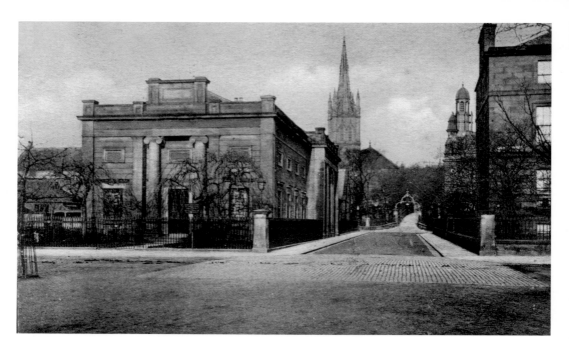

Montrose Museum

Montrose Museum, facing the mid links, is built in the Grecian style. It was founded in 1839, opened in 1842 at a cost of £1,200, and extended again in 1899 at a cost of £1,500. It is tastefully filled with one of the finest collections in Scotland. More recently, the museum has had improvements both inside and outside.

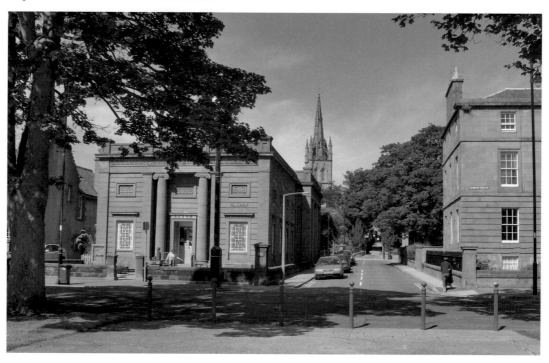

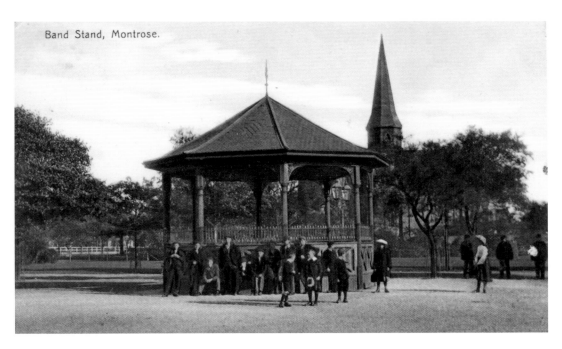

Band Stand, Montrose.

The Bandstand

The bandstand in the early twentieth century with St Peter's steeple in the background and the Dean's lamp visible between the pillars. By the early 1950s the bandstand was becoming a liability and was hardly ever used. It was then demolished.

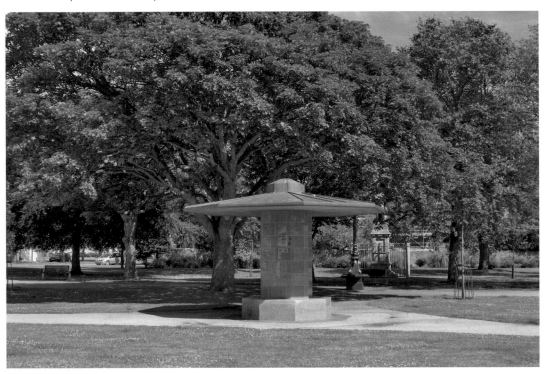

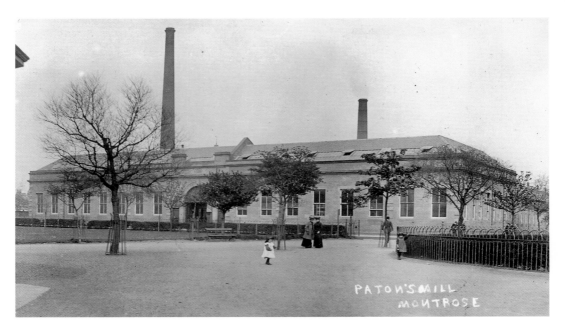

Paton's Mill

Paton's Mill was a large employer of local people, including the women of Ferryden while their men were fishing at sea. The rear area of the mill has now been transformed into flats and houses. Only the front area remains, presently waiting completion.

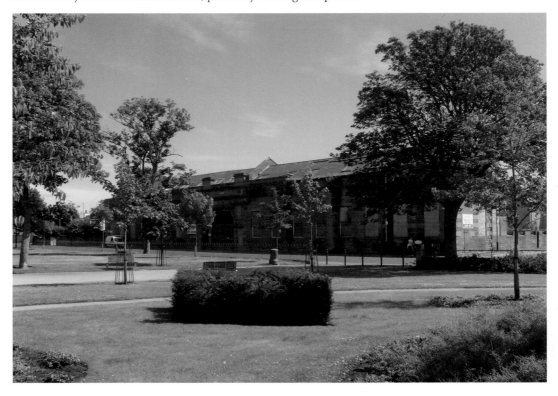

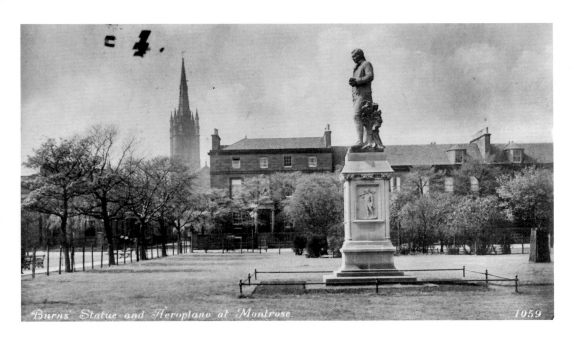

Burns' Statue and Aeroplane at Montrose. 1059

The Robert Burns Statue

Burns' statue, designed by J. Birnie Rhind, was unveiled by Andrew Carnegie in 1912. Surplus money which was raised for the statue was used for cleaning the gravestones of Burns' forebears in Glenbervie churchyard, and to place a brass plate on the house in Bow Butts where Burns had stayed overnight with his cousin, James Burnes. Metal railings have now been erected around the statue.

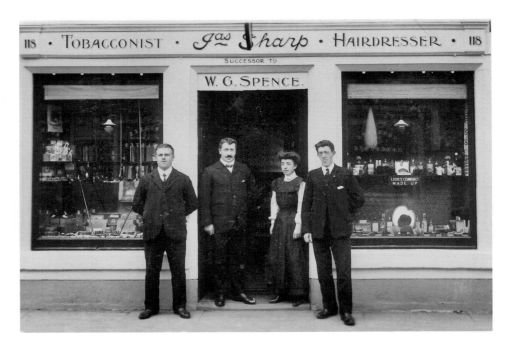

Murray Street

Jas Sharp, Tobacconist and Hairdresser, 118 Murray Street, was one of many similar shops in the early 1900s. This view shows the four well-dressed members of staff at the door. A charity shop presently occupies the site.

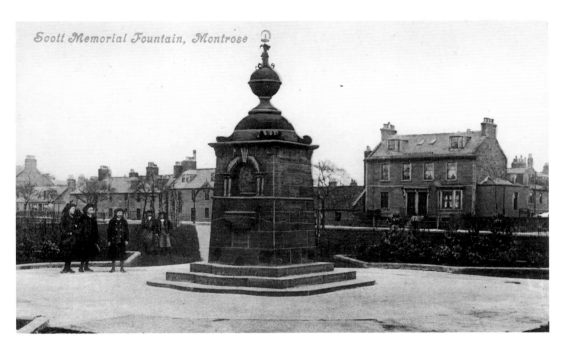

Scott Memorial Fountain, Montrose

The Provost Scott Memorial

Work started on the Provost Scott memorial fountain in 1903 by Messrs. Reid & Burnett, Montrose, and was erected in the centre of Scott Park. The unveiling ceremony took place on Saturday 21 May 1904. This view is looking east through the park, with the trees now all fully grown.

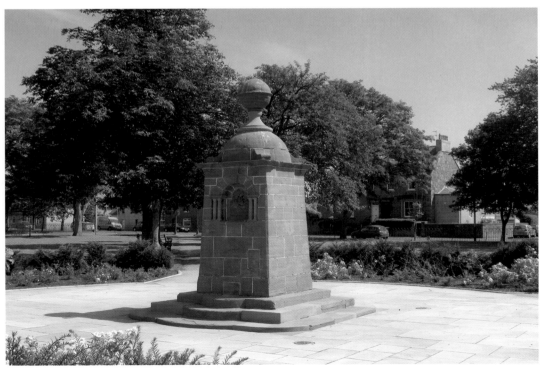

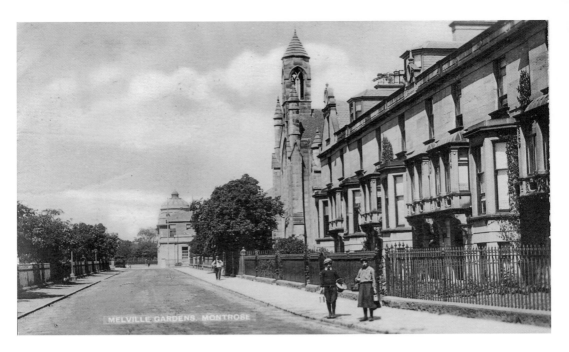

Melville Gardens

Melville gardens looking towards Montrose Academy, with the Melville church on the right. This church was converted to the new Montrose town hall and was opened in 1963. The railings of the Melville bowling green can be seen on the left.

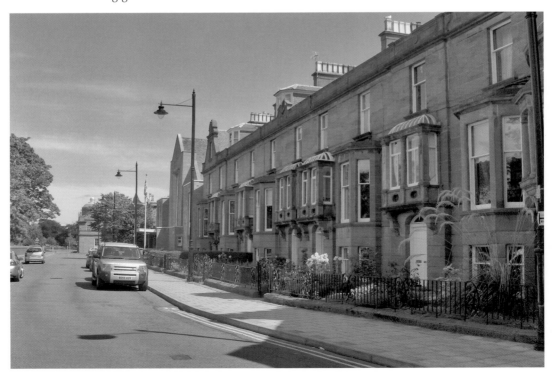

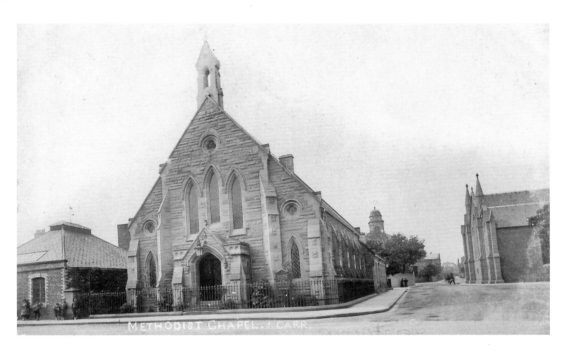

The Methodist Chapel
The chapel is still at the junction of New Wynd and Mill Street; what was a blacksmiths' premises to the left of the chapel is now private housing. St Johns' church in John Street can be seen in the background.

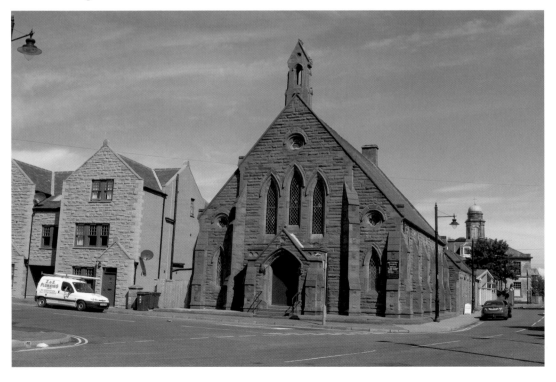

John Street

Looking east along John Street, the Park Hotel can be seen in the background. Montrose Registry Office is on the left. Little has changed here, apart from the large trees having been cut down and most of the metal railings are now gone.

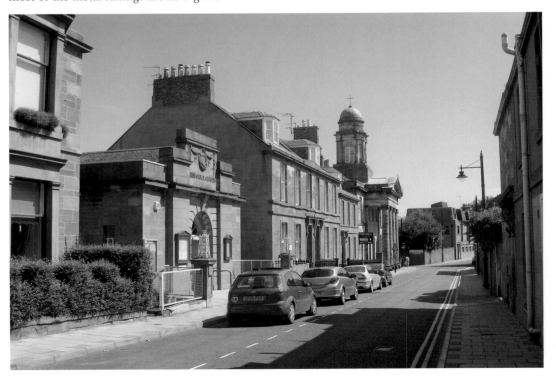

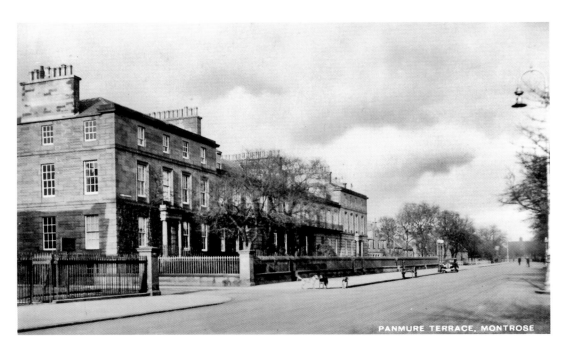

PANMURE TERRACE, MONTROSE

Panmure Terrace

Panmure Terrace looking north, with its grand row of private housing. The museum entrance is to the near left and some railings have survived the Second World War. Robert Burns' monument is in the park to the right.

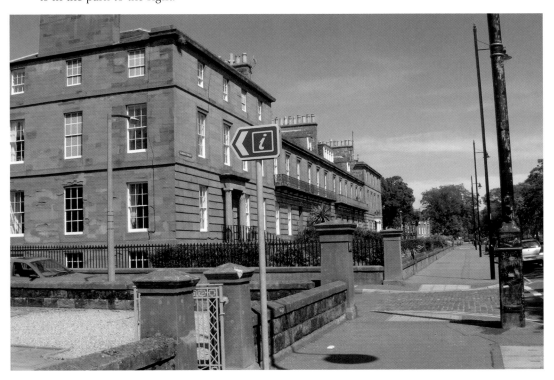

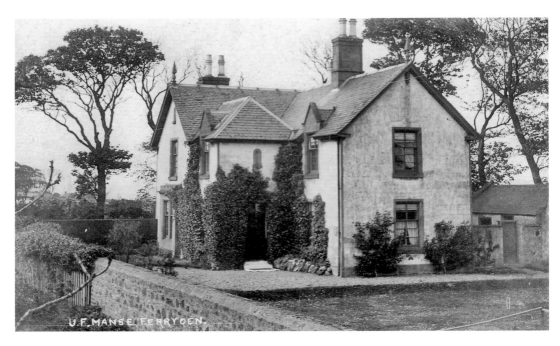

The Manse

The United Free Church manse can be found on the Ferryden to Usan road. Little change here for this early Victorian house which has served as the home for the ministers of the Ferryden United Free church, in Bellevue Terrace.

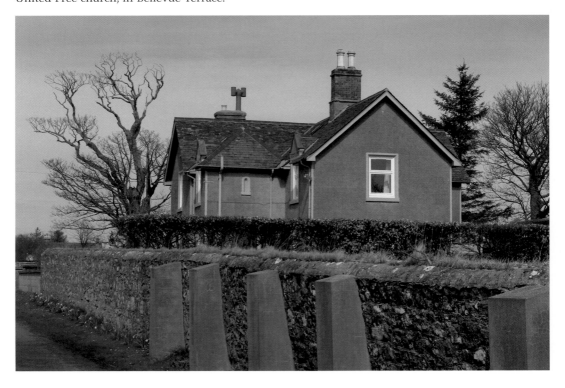

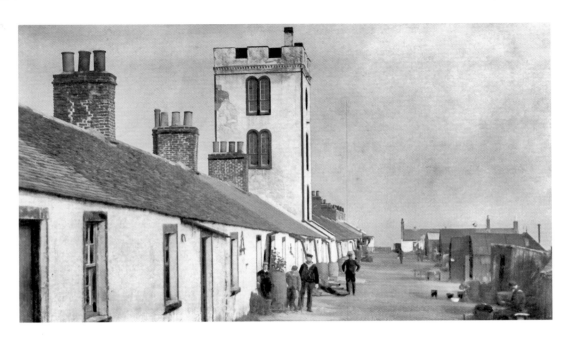

Usan

Lying behind Ferryden is the old fishing village of Usan. The row of houses is now in ruins, but a local salmon fishery business still survives. In years gone by the prevailing name here was Paton, with one or two Perts and Coulls (Ferryden names). This had been brought about by marriage of Patons from Usan to Ferryden folk.

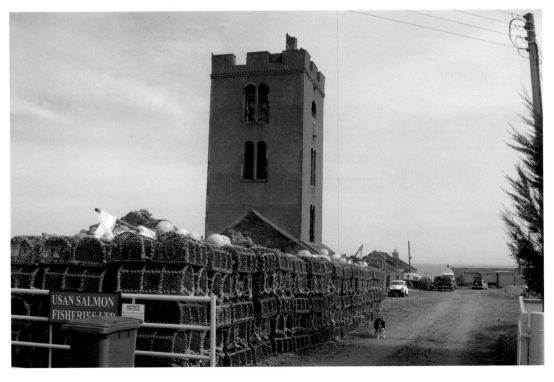

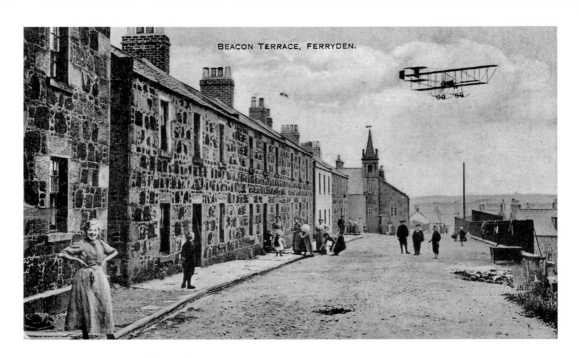

BEACON TERRACE, FERRYDEN.

Beacon Terrace Towards Rossie Terrace

Beacon Terrace, looking west towards Rossie Terrace, Ferryden. The old primary school can be seen in the background, with only a part now remaining. The building on the extreme left is the only three-storey house in Ferryden.

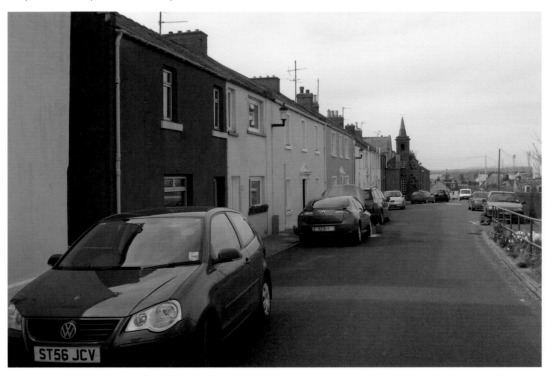

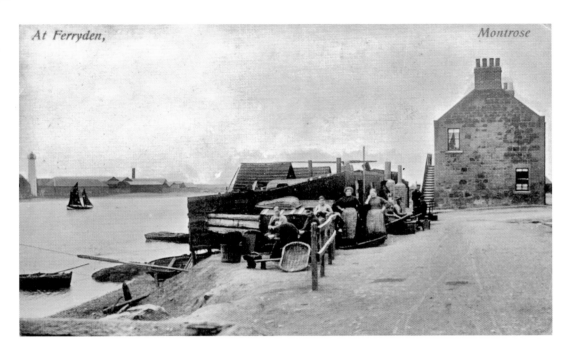

At Ferryden, *Montrose*

Brownlow Place, Ferryden

This view looks east across Brownlow Place, showing fisherwomen busy repairing and baiting nets. Some fishermen helped out if they were unable to go to sea. This site is now where the local shop and post office stands.

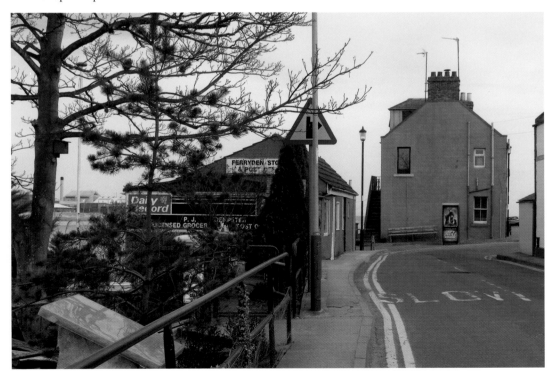

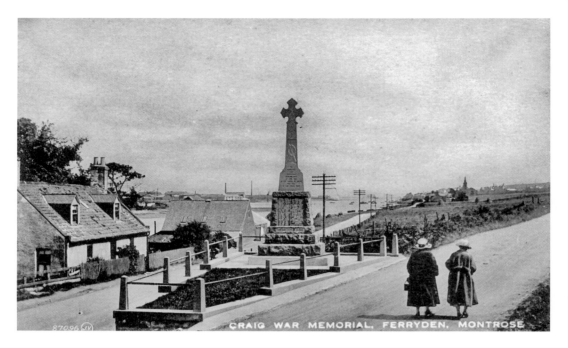

CRAIG WAR MEMORIAL, FERRYDEN, MONTROSE

Craig War Memorial

From the Craig war memorial, we look east along Burnside Place, Ferryden. This war memorial was later moved up to the Ferryden playing field. Most of the council housing was built along Burnside Place just before the Second World War. The estuary of the River South Esk on the left was dredged and filled in when the Sea Oil base was built in the 1970s.

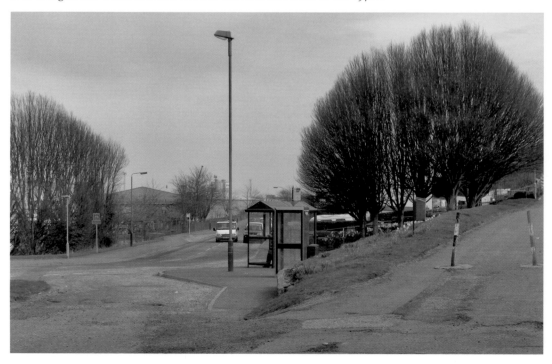

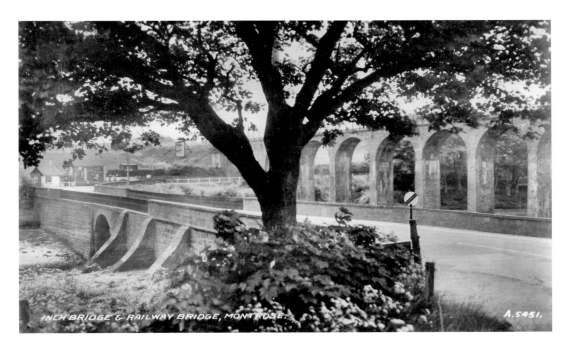

INCH BRIDGE & RAILWAY BRIDGE, MONTROSE. A.5451.

Montrose Bridges

The railway bridge which carries the Aberdeen to London railway line still stands. The Inch Bridge has now gone, and a busy roundabout has taken its place. This was re-developed when the Sea Oil base was built.

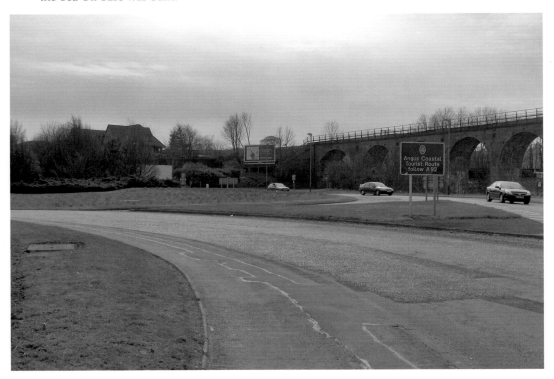

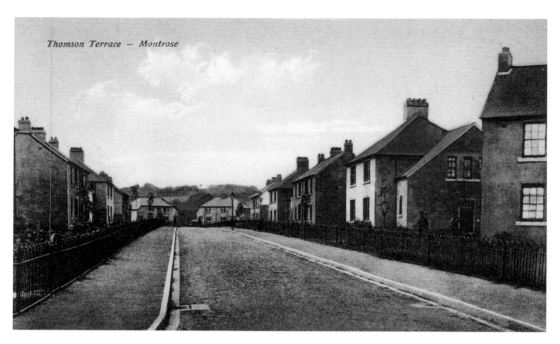

Thomson Terrace — Montrose

Thomson Terrace

Little change here at Thomson Terrace, on Rossie Island. This housing scheme was initiated in 1919. The metal railings have mostly gone and a few house alterations can be seen.

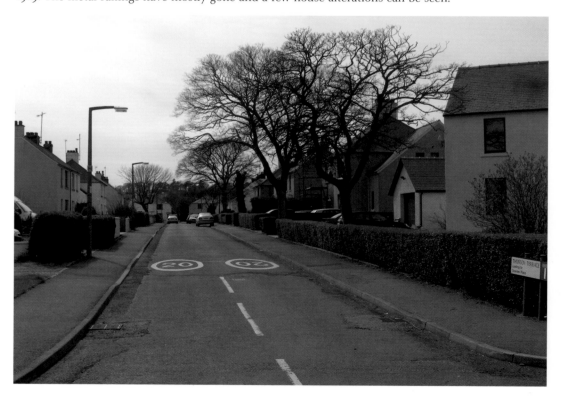

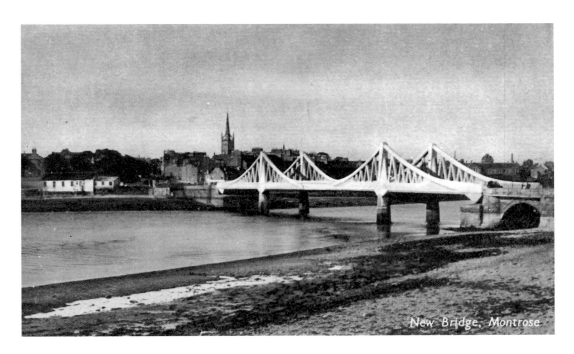

New Bridge, Montrose

The New Bridge

The New Bridge looking east; this spanned from Rossie Island to Bridge Street, Montrose. It was opened in 1931 at a cost of £77,774. A cantilever bridge built from reinforced concrete, this was the only one of its kind in the world. Due to the strain it was receiving from modern traffic, it was dismantled in 2004 and a replacement built by 2005.

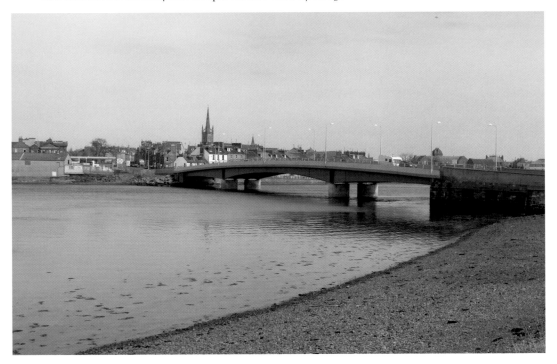

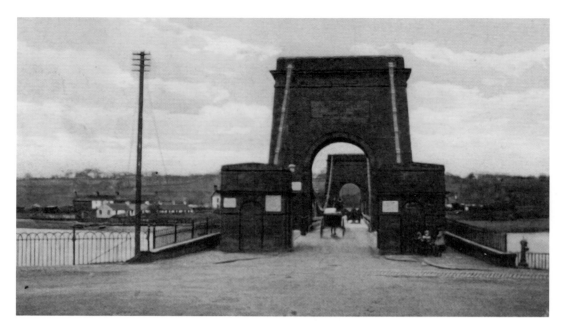

Towards Rossie Island

A view of the old suspension bridge, looking south towards Rossie Island. Prior to being demolished in 1930, this bridge suffered severe damage to its chains due to bad weather. Note the old water well to the right, and the horse and cart crossing the bridge.

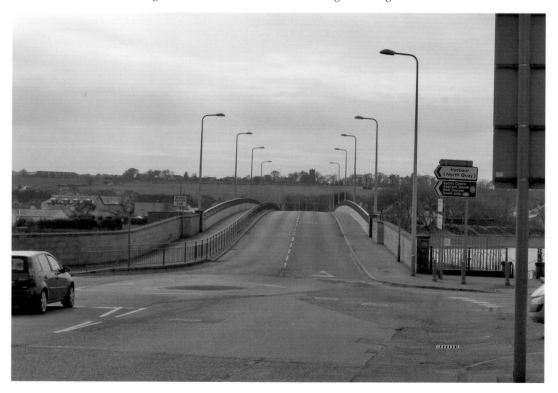

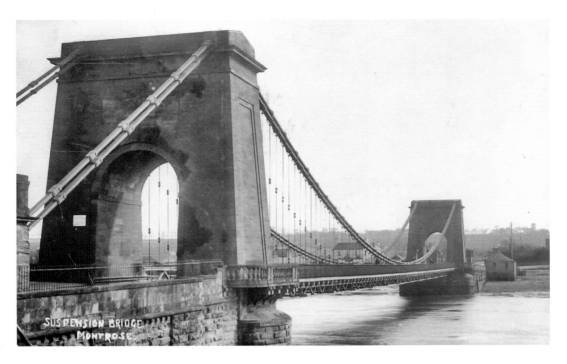

The Old Bridge

The old suspension bridge, looking from the west. A most beautiful structure, but as it weakened and suffered from weather damage, it was decided to replace it with the new bridge in 1931. This also shows the 2005 bridge from west.

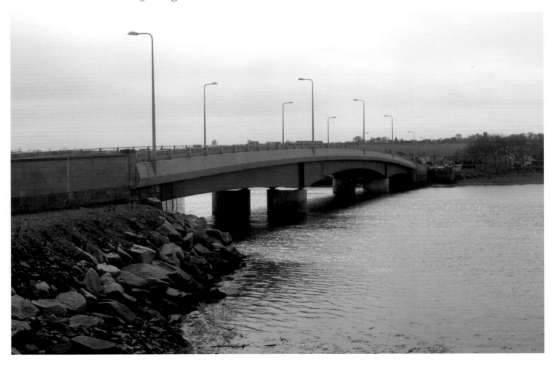

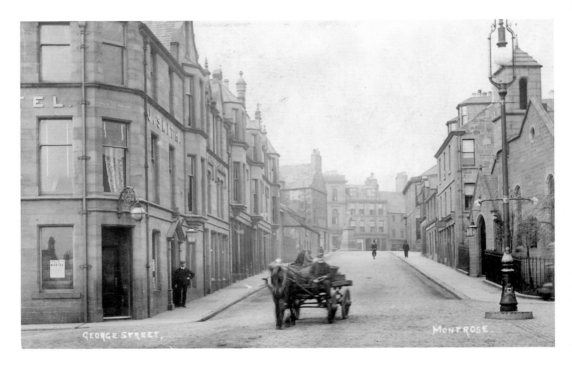

George Street

This photo looks along George Street, towards the High Street. The George Hotel can be seen on the left, and the former St Andrew's church on the right. This church was more recently used as a cinema. The metal railings outside the church have now gone.

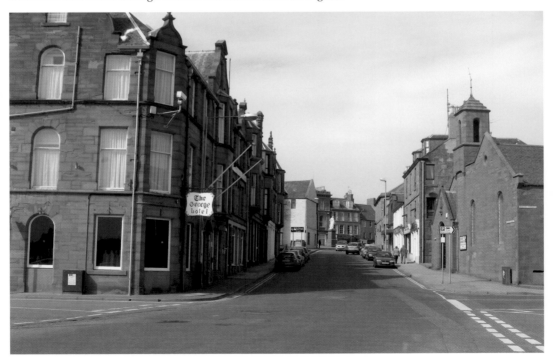

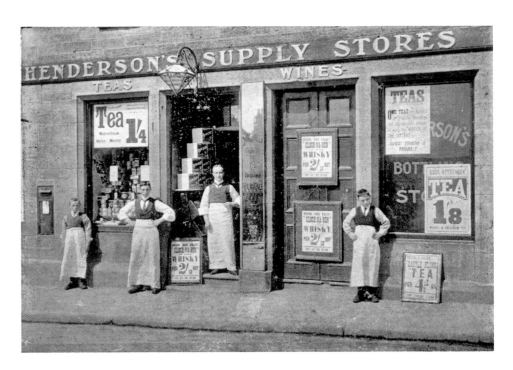

Castle Street

Henderson's Supply Stores occupied 94 and 96 Castle Street, which are now private residences. This was one of the many small shops in this street that have disappeared over the years. The post box probably got taken away when the main post office moved from the High Street to nearby Bridge Street in 1907, so then there would be posting facilities there.

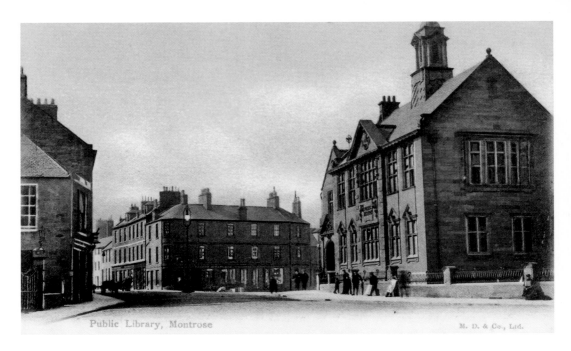

Public Library, Montrose

M. D. & Co., Ltd.

Montrose Library
The public library is at the junction of High Street, Castle Street and Bridge Street. Built with the money of Andrew Carnegie, it is a fine example of Edwardian architecture and was opened by John Morley MP in 1905.

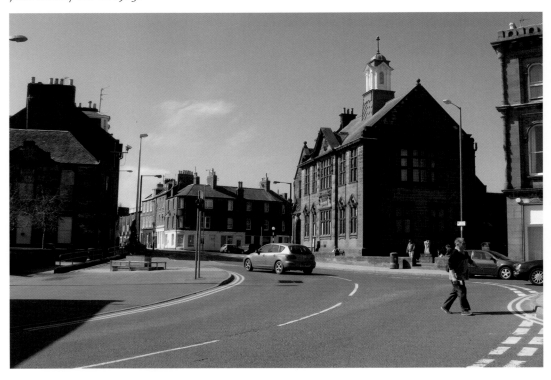

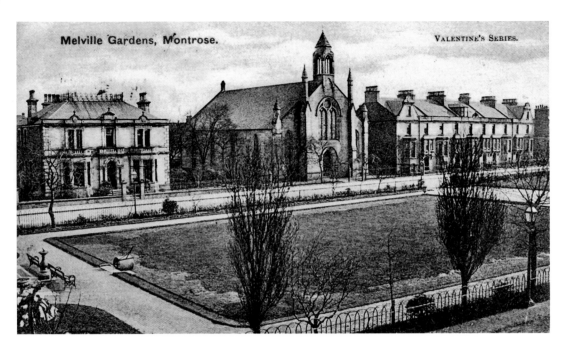

Melville Gardens

Melville gardens, showing the bowling green and Melville church (later to become the new town hall in 1963). Melville gardens were opened in 1876. Even the sundial at the bowling green has stood the test of time.

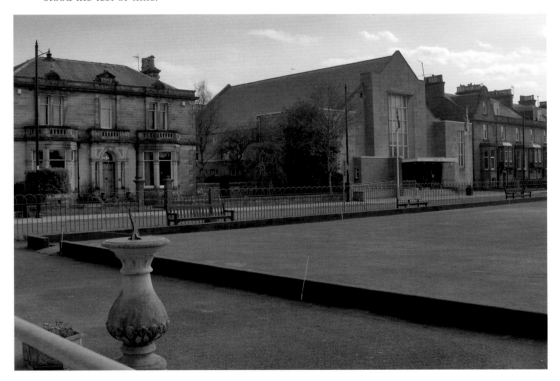

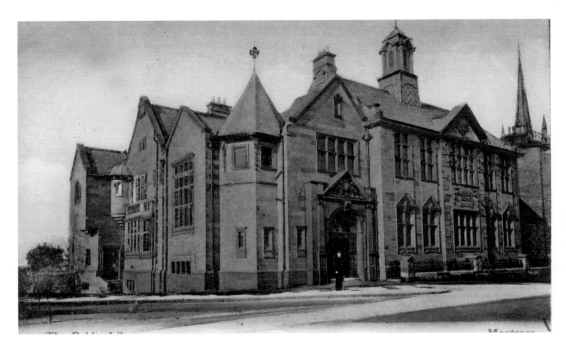

The Library

The public library looking north, with the steeple in the background. There is little change to this fine Edwardian building except that the outside looks fresher and the inside has experienced renovation work over the years.

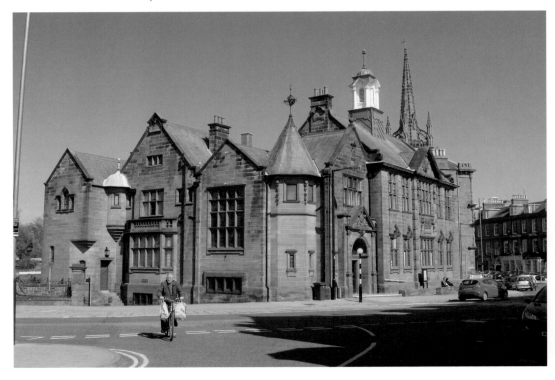

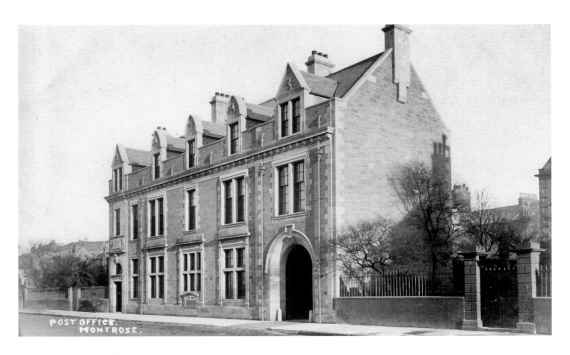

The Post Office

The post office was originally in the High Street, and moved to Bridge Street in 1907, when it opened at a cost of £5,500. In 1993, it again moved back to the High Street, at the Co-op premises. This building is still used as a sorting office and pick-up point for mail.

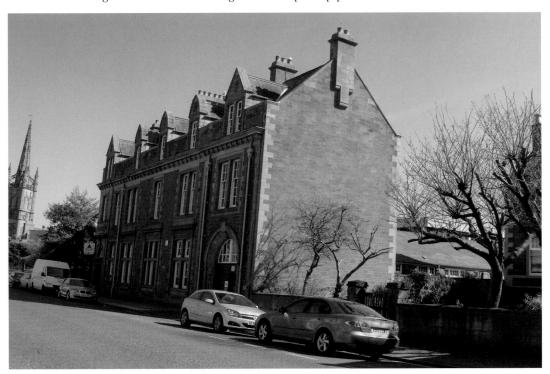

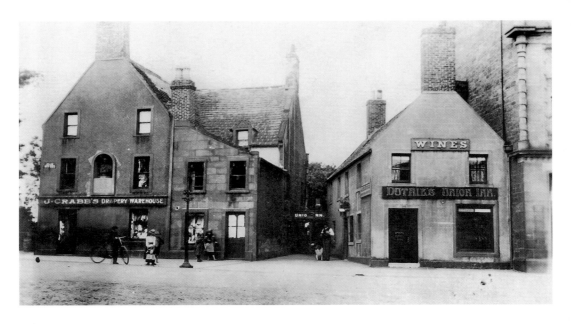

Robert Brown

J. Crabb's Drapery Warehouse stood at the corner of the High Street and Mill Road. In this house Robert Brown was born, who became the most celebrated botanist in the world. Next to this building was Duthie's Union Inn. The Montrose library now stands in their place.

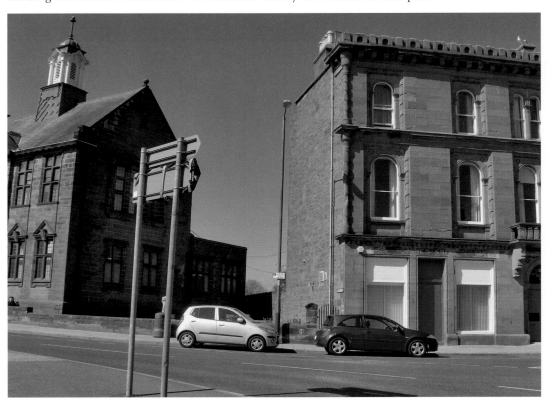

54

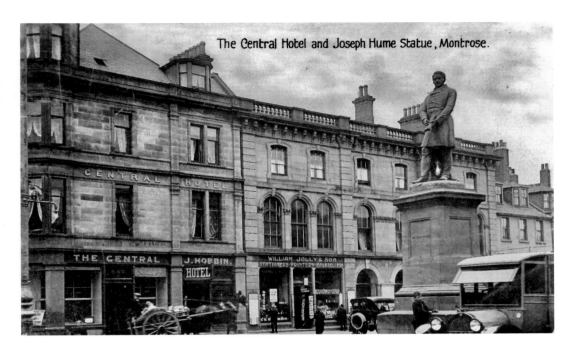

The Central Hotel and Joseph Hume Statue, Montrose.

The Hume Statue

These images look west across the centre of the High Street, towards the Central Hotel, showing the Hume statue. In 1859, when workmen were digging the foundations for this statue, they discovered the only medieval hoard that has ever been found in Montrose.

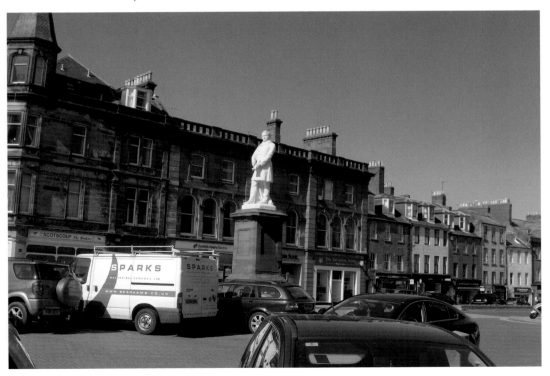

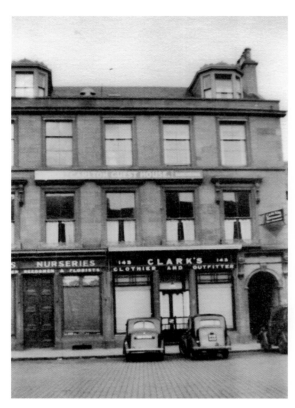

The Carlton Hotel
From the High Street, we look across towards the Carlton Guest House. This is now the Carlton Hotel and the names of the shops below it have changed. Also, the cobbles on the street have now long gone and been replaced with tar.

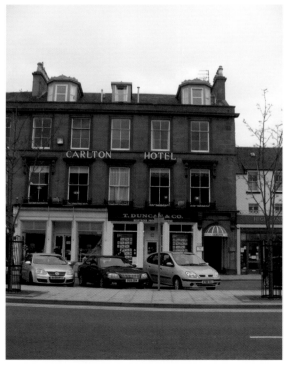

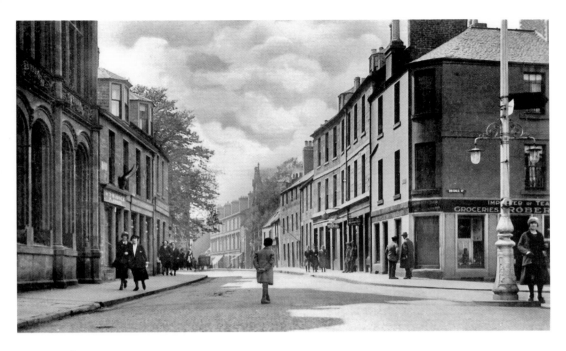

Castle Street

Looking south down Castle Street. This street was once full of small shops and stores, which have mostly all gone now. In early times, this area was a great howff for foreign seamen, including Danes, Swedes and Norwegians. The savings bank building which can be seen on the left was erected *c.* 1900.

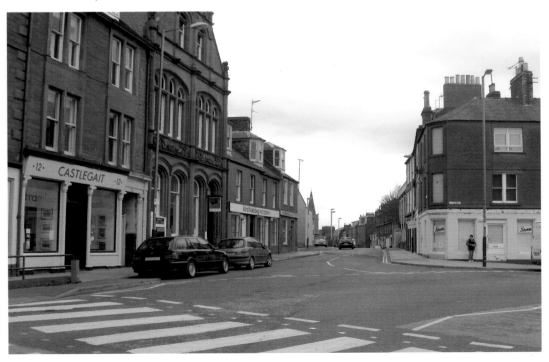

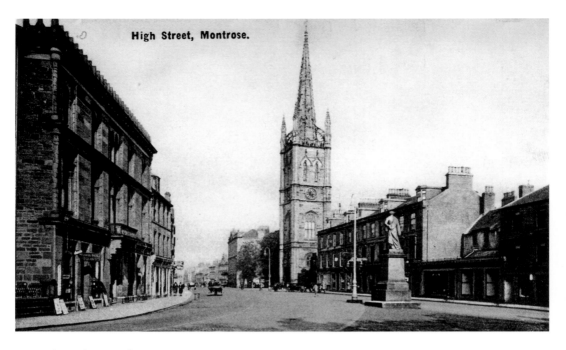

High Street, Montrose.

The Robert Peel Statue

The High Street, looking north towards the steeple, showing the Robert Peel statue. This steeple was built 1832–34, and is about 220 feet high. This part of the High Street has been divided, with parking facilities to the right hand side.

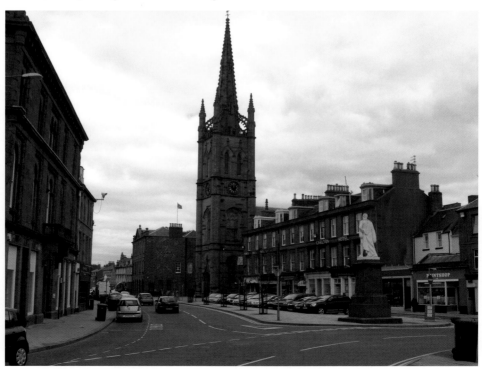

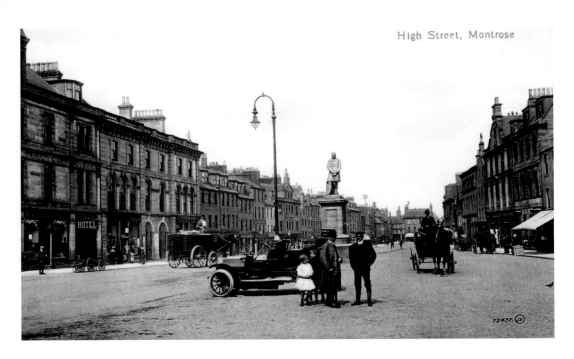

Central High Street
The central High Street looking north, with the Hume statue, showing the mode of transport of the time. This area has also been transformed to include parking facilities. Little change here to the actual buildings.

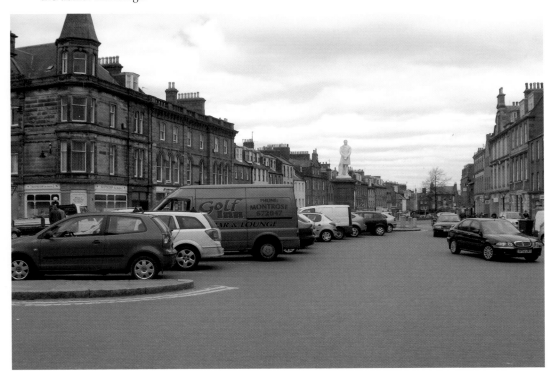

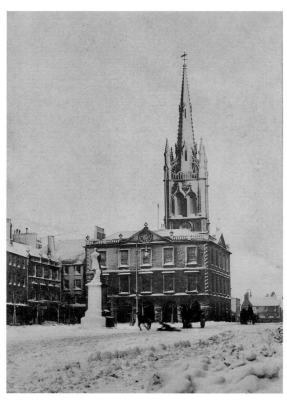

The Steeple
The steeple and town house looking south. In 1906, there were exceptional snow blizzards in Montrose, with the town cut off for several days. The telegram and telephones were interrupted for a fortnight.

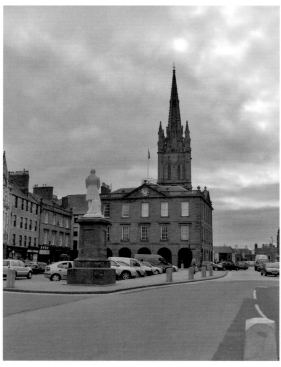

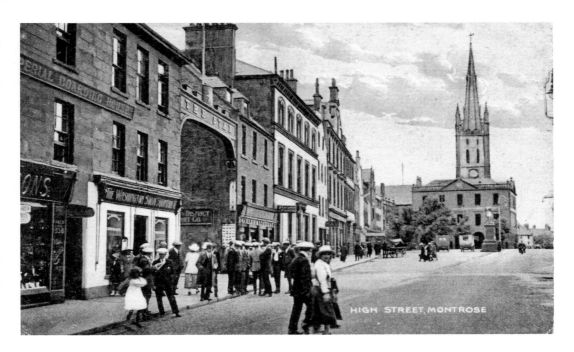

The Star Hotel

The High Street, looking towards the top of New Wynd. The Star Hotel arch stood for over 100 years, and was removed when the stationers to its right was demolished. Moves have been ongoing over the past few years to have a new arch built.

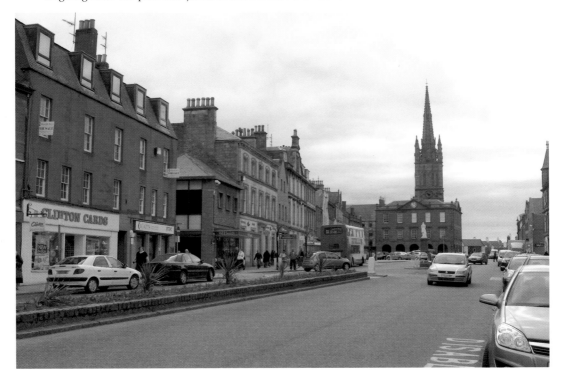

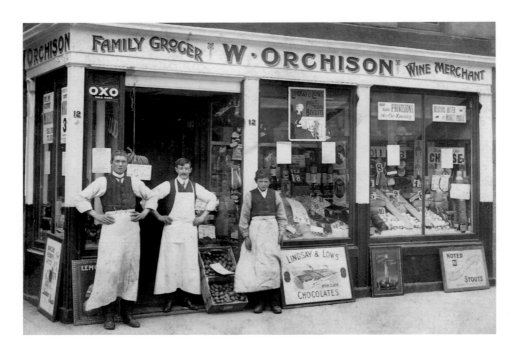

Orchison's

W. Orchison's family grocer and wine merchant was at 12 High Street in the early 1900s. This view shows the three staff members at the door. Jas Vettese, newsagent occupied this shop for many years between the 1950s and the 1970s. The latest occupier was the 'Best Wishes' gift shop.

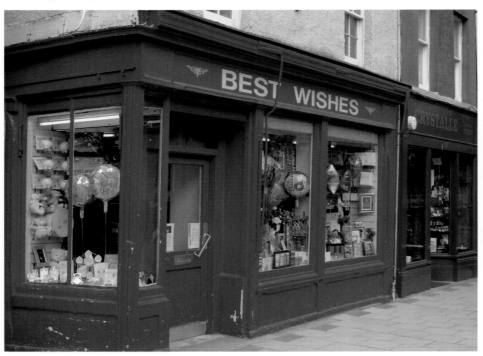

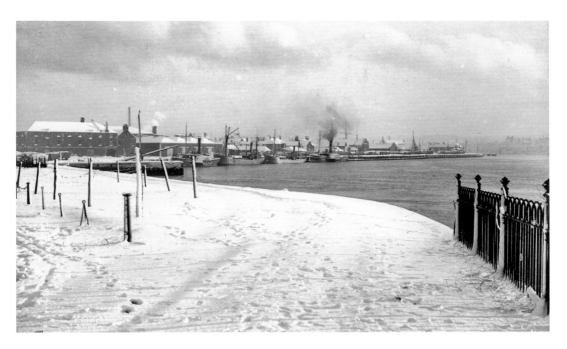

The Chivers Factory

View looking east towards the jetty and the Chivers factory, showing several old steam boats which were probably loading potatoes and beer. Chivers factory was badly damaged in a bombing raid during the Second World War. New buildings now occupy this site.

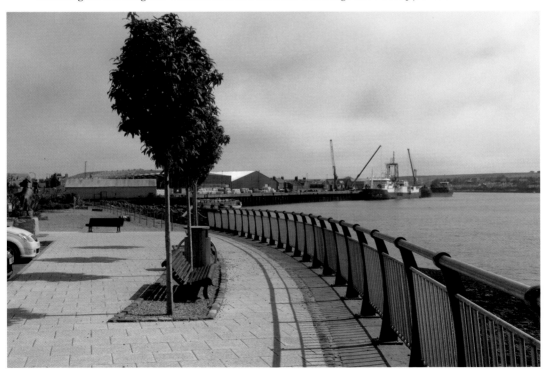

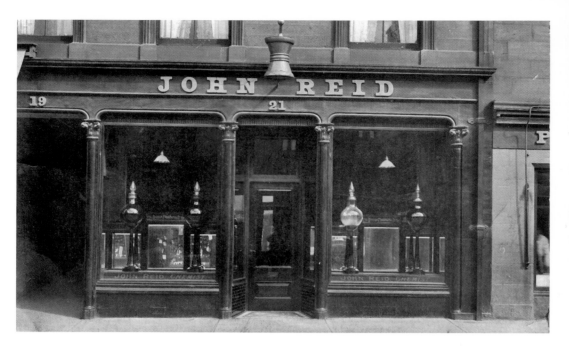

John Reid
John Reid was a long-established chemist in Montrose, and this shows the shop at 21 High Street.
Note the mortar and pestle above the door, which was a common sight outside chemist shops.
The present occupier of this shop is an outdoor clothing business.

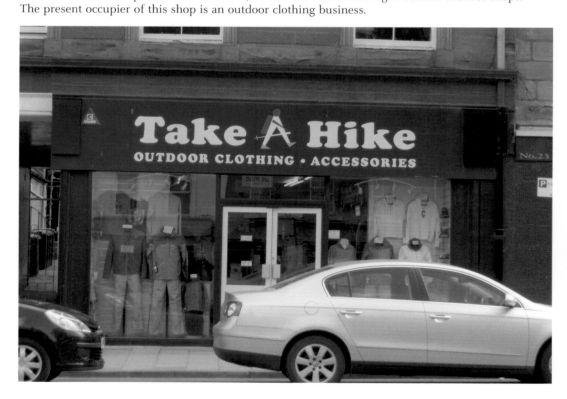

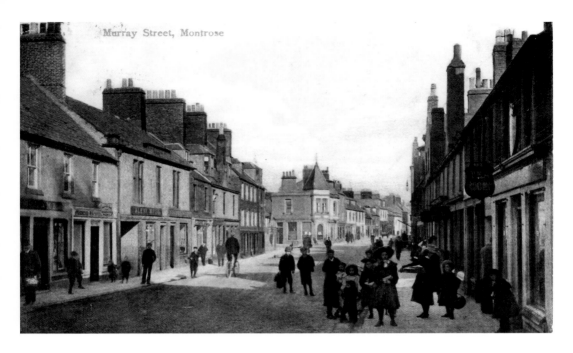

Murray Street

Murray Street looking north; this was a continuation of the High Street, but a lot narrower. The Black Horse Inn can be seen in the background, and little has changed here. Murray Street has always been a popular street, because of its small shops and tea rooms.

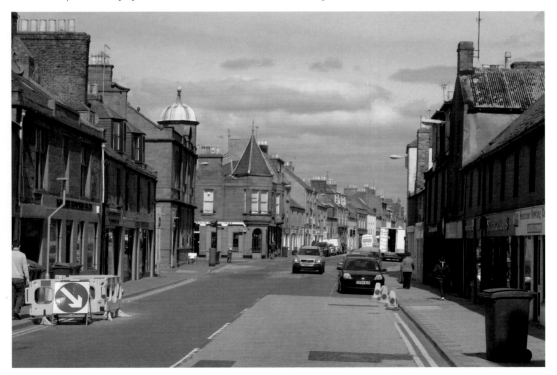

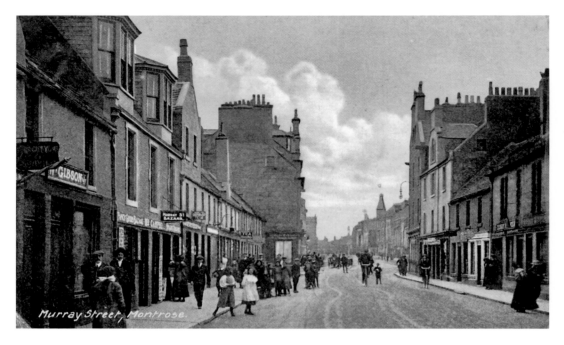

Murray Street

Murray Street, looking south towards the High Street. Here you see where it actually joins the High Street at the 'Port'. A selection of shops, such as bazaars and a tea room, can be seen on the left.

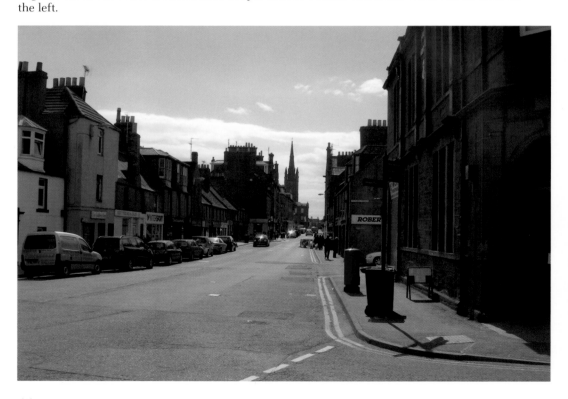

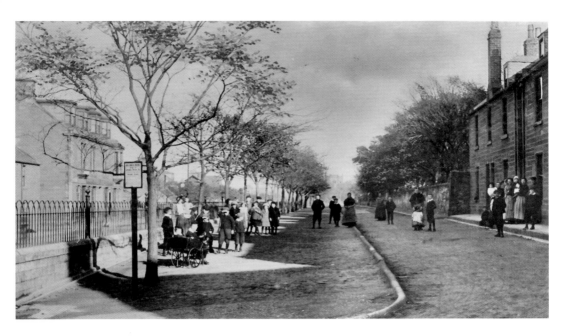

The Mall

The Mall ran from the top of North Street to Rosehill. The housing area on the right is where the present swimming pool now stands, and car parking facilities were made to the left of the new, widened road.

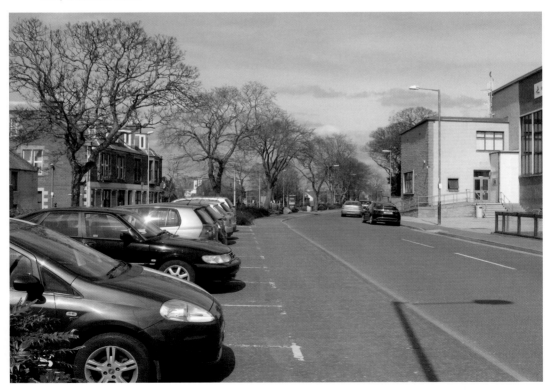

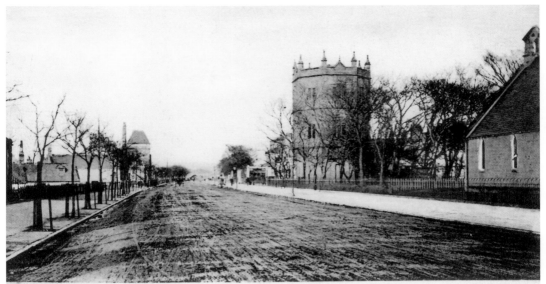

Part of Northesk Road. Montrose.

Northesk Road

Northesk Road looking north with the now-demolished Lochside Distillery in the background. The old water tower and the Lochside church can be seen on the right. Alterations to the nearside road area were made when the Montrose bypass was constructed.

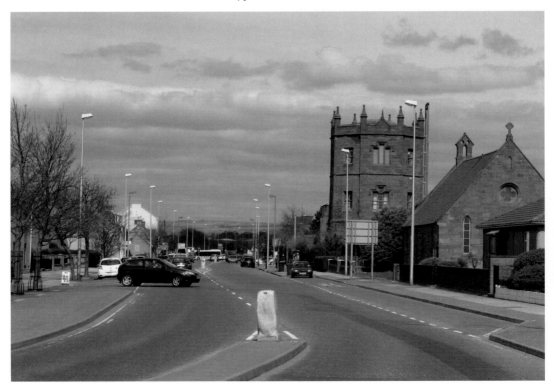

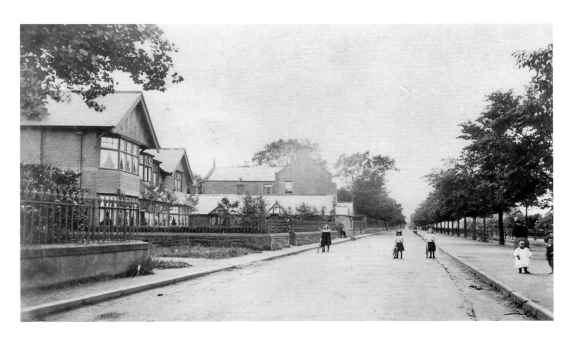

The Mall To North Street

The Mall looking south, towards the top of North Street. The Mall is one of the finest promenades in the town, and was originally improved many years ago by having a nice concrete wall built with an iron railing on top of its entire length. Those railings were left during the Second World War but the ones outside the houses have gone, replaced with hedging.

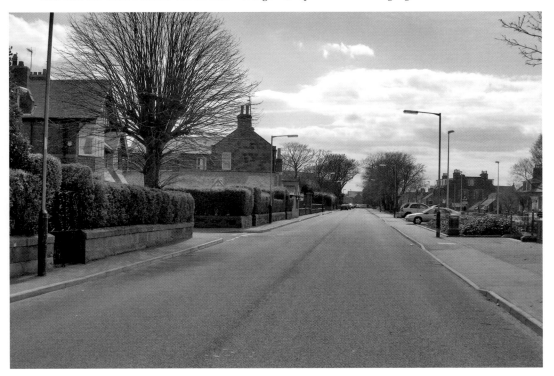

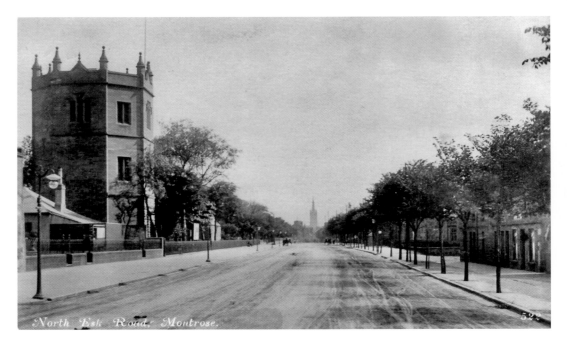

Northesk Road

Northesk Road looking south, with the steeple in the background. The old water tower on the left was converted to living and office facilities in the 1970s. Some of the roadside trees on the right have now gone.

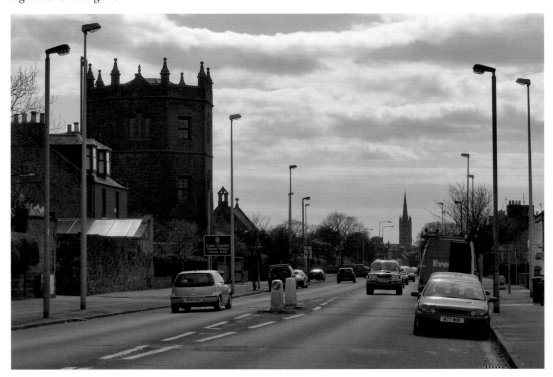

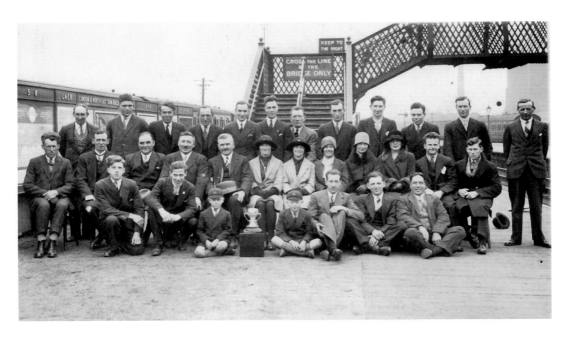

Travellers at Montrose

Unknown party of people, which may have arrived off a train or been ready to depart at Montrose Railway Station, with a trophy. The two children in the front are wearing Montrose Academy caps. Note the tall chimneys in the background, which have all long disappeared.

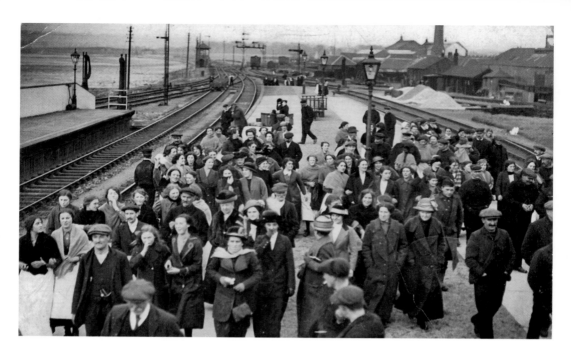

Montrose Railway Station

It is said that this image shows local women from Montrose and Ferryden, having just said their goodbyes to their relatives and loved ones at the railway station during the First World War. New buildings and a supermarket have now replaced the buildings on the right.

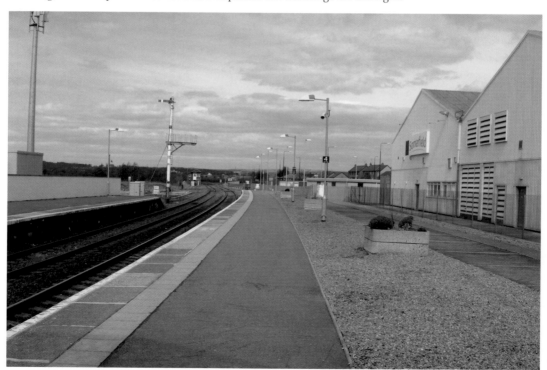

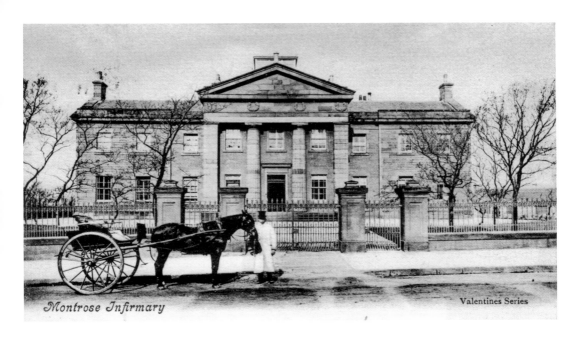

Montrose Infirmary

Valentines Series

The Infirmary

The Montrose Infirmary in Bridge Street was built in 1839 and opened on 19 December of that year. The site favoured at the time was known as Constable Hill. Extensions to the original building were completed in the later 1800s, and again in the 1920s. A sun balcony was added to the upstairs ward in 1937. The metal railings and gate are now away, but little has changed to the front of the building.

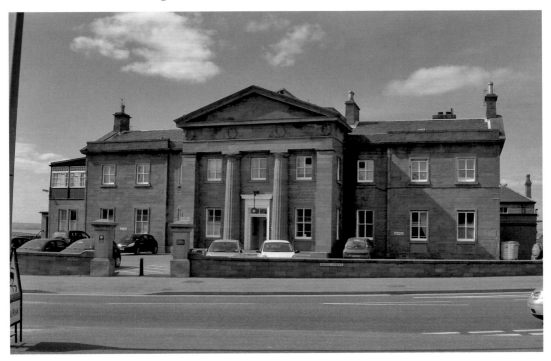

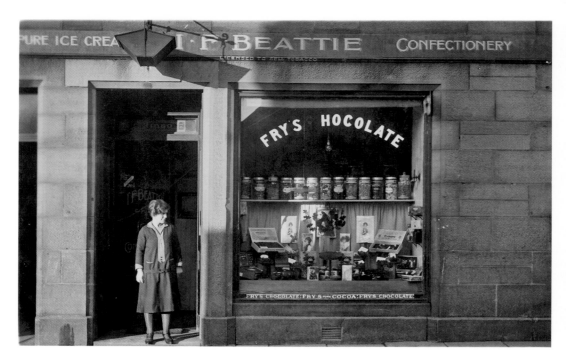

Beattie's

Beattie's confectionary and ice cream shop was another one of Castle Street's many small stores. It was situated at Number 84 between the years 1928 and 1944. Since then, it has been a laundry and is presently a private residence.

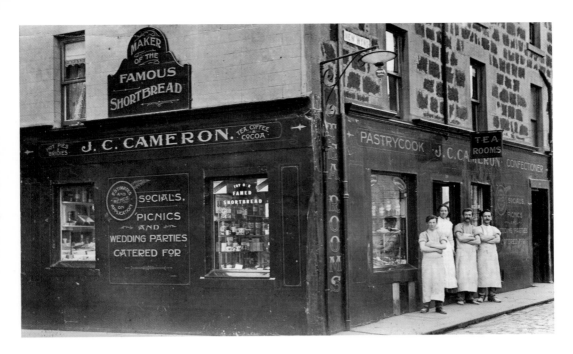

The Tea Room

J. C. Cameron's pastry cook, confectionery and tea room stood at the junction of New Wynd and Market Street. This view shows four members of staff at the door and dates from the 1920s. A dog grooming business now occupies this shop.

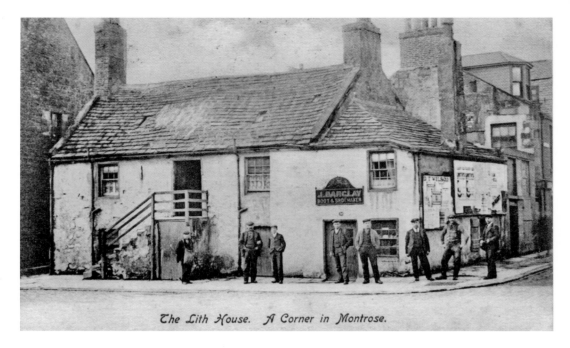

The Lith House. A Corner in Montrose.

The Lith House

The old Lith house (or Lit house) stood at the corner of Murray Street and Lower Hall Street. It is not known where its name originated from, but a flax dying business is said to have operated there until the mid-nineteenth century. The Montrose YMCA building now stands on this site.

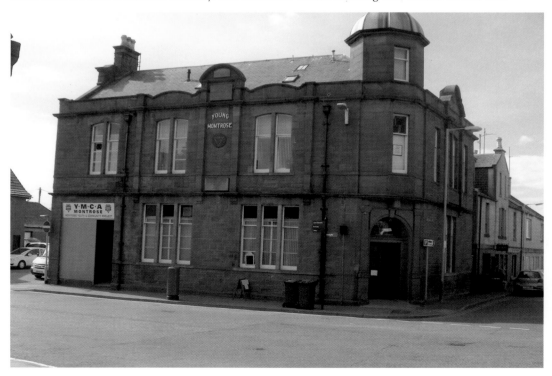

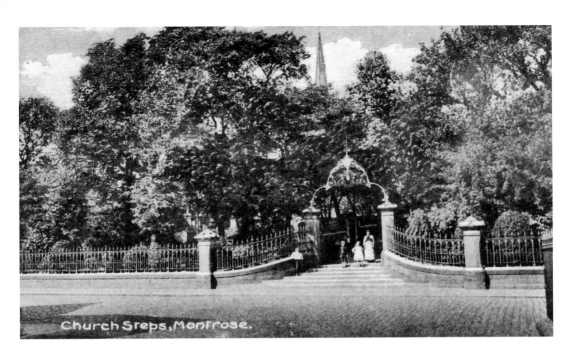

Church Steps, Monfrose.

Church Steps

Following up the steps, this walk takes you from Baltic Street to the Old Church on the High Street, while passing the old churchyard which contains many tombs of the local gentry. Very little has changed here, with the metal railing still intact or perhaps replaced.

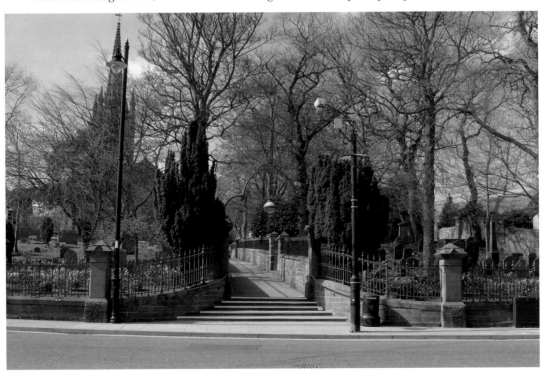

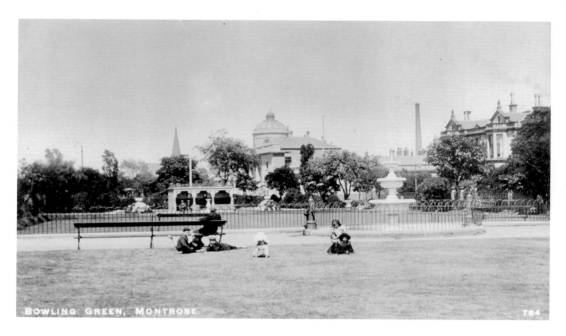

Melville Bowling Green

An early view of the Melville bowling green, showing the original shelter and water fountain at the front. The new clubhouse replaced the old one, and the fountain is now away. The Montrose academy can be seen in the background. The Melville gardens were opened in 1876.

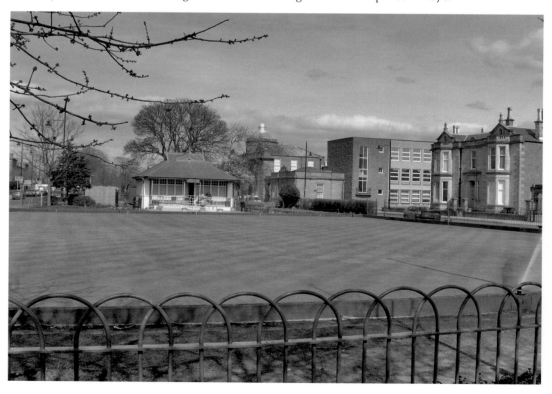

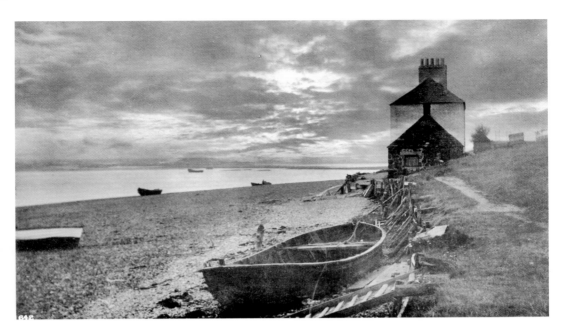

Esk Road

Esk Road is a small branch road off Rossie Island Road which runs alongside the Montrose basin. This house, as well as being a private residence, had a bothy at the front for the salmon fishers to stay. This house has all been recently renovated.

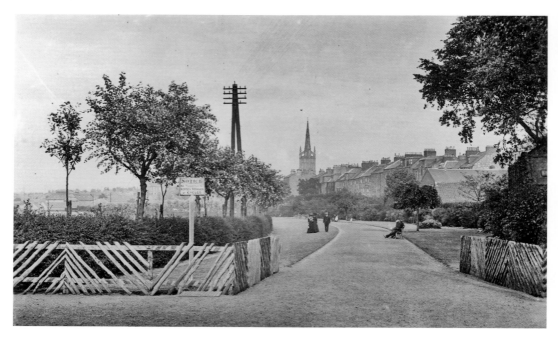

The Park

This delightful park was reclaimed from the Montrose Basin by the construction of the North British Railway. The park was laid out in 1890 with flowers, grass and trees, and seats were also provided. The southern entrance all changed when the Montrose bypass was built.

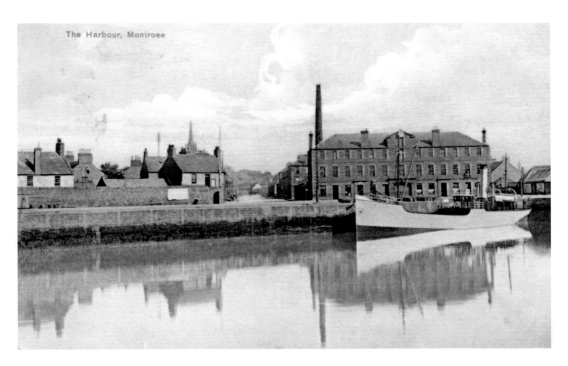

The Harbour, Montrose

The Harbour

The harbour, with the dock buildings behind. This building once had a sub-post office in it which opened in 1882 and closed in 1915. The dock has now been filled in and storage sheds have been built.

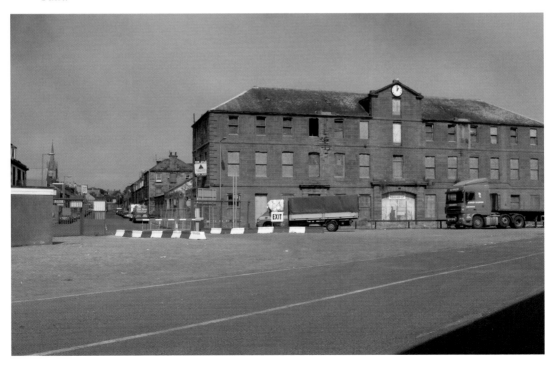

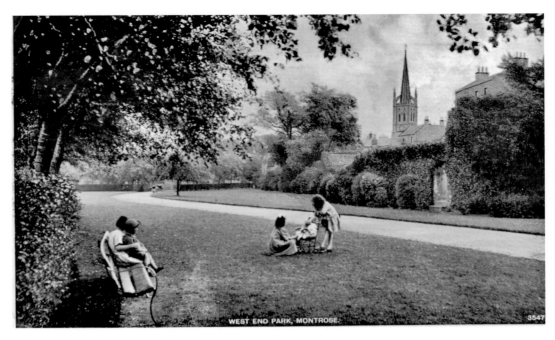

The Park
The west end of the park, looking towards the north entrance. This park is much frequented by walkers and is finely sheltered from the east winds by the high walls and houses of Bridge Street. This was one of the late Provost Scott's pet schemes.

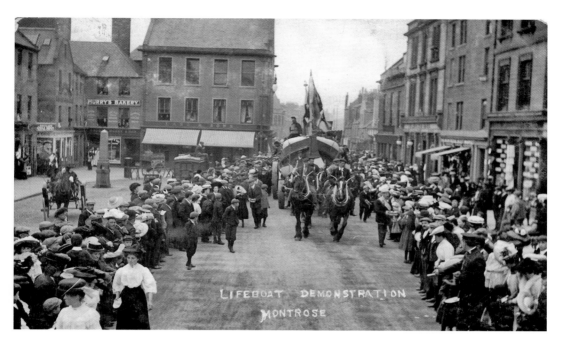

The High Street

The High Street, looking towards Murray Street. Lifeboat demonstrations were very popular in the town at the beginning of the 1900s, when Clydesdale horses pulled the lifeboat (which was put on wheels) around the streets.

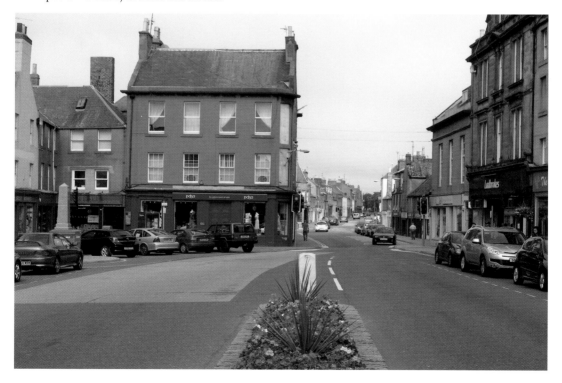

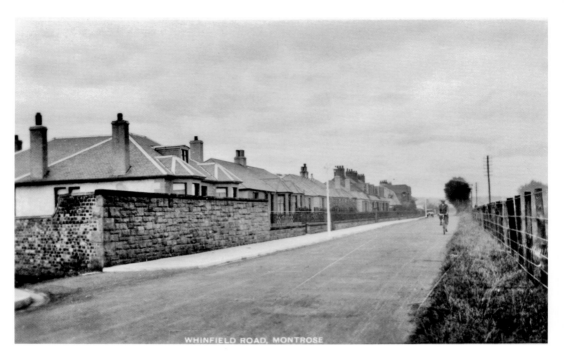

WHINFIELD ROAD, MONTROSE

Whinfield Road

Whinfield Road runs partly along beside the golf course, and will take you to the 'curly' pond. There have been few changes to the houses, but a cycling path has been built to the right.

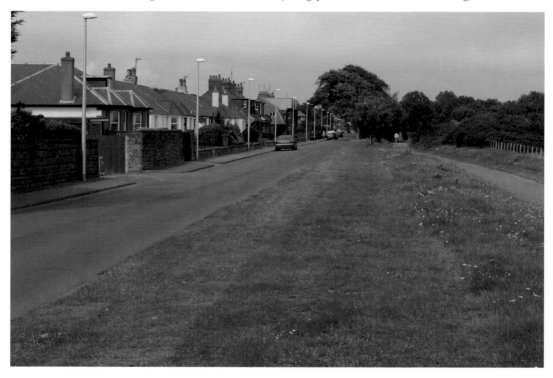

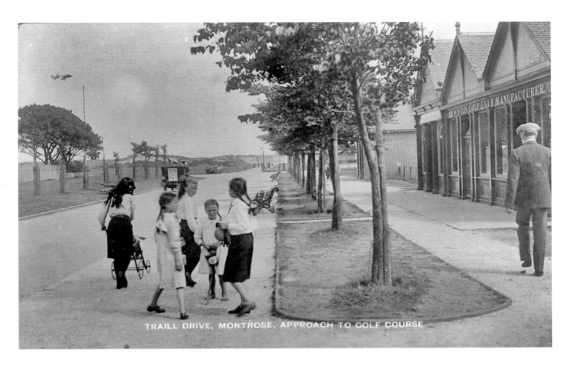

TRAILL DRIVE, MONTROSE, APPROACH TO GOLF COURSE

Trail Drive, Looking East

Trail Drive, looking east towards the golf courses. On the right can be seen the premises of Wintons', the golf club manufacturers. The Caledonia Golf Club is now on this area and the trees seen at the side of the pavement have all gone.

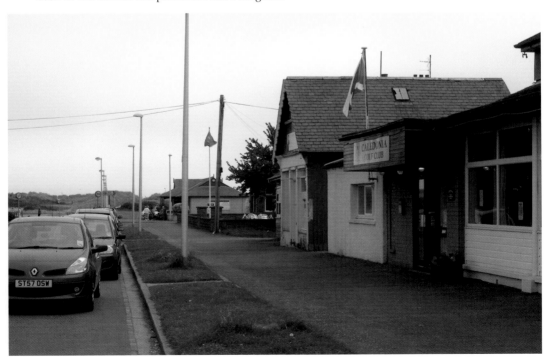

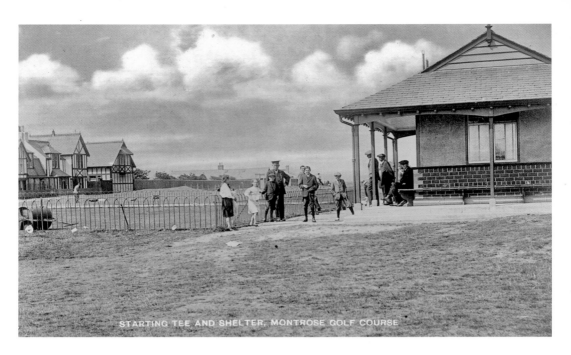

STARTING TEE AND SHELTER, MONTROSE GOLF COURSE

Montrose Golf Course
The starting tee and shelter at Montrose Golf Course. This has been extended over the years, with car parking facilities to the left. There is also now a golf shop on the premises.

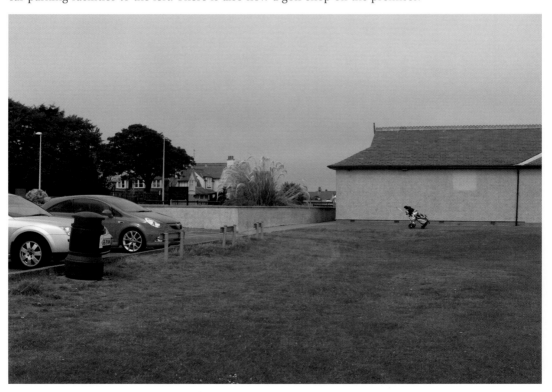

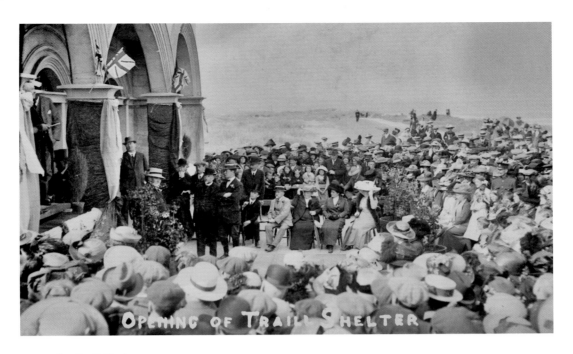

OPENING OF TRAIL SHELTER

The Trail Shelter

The Trail shelter is situated at the beach front on the Trail Drive. It was opened in 1912. Recently, over the years, this area of the beach has all been revamped, but the shelter has remained basically the same.

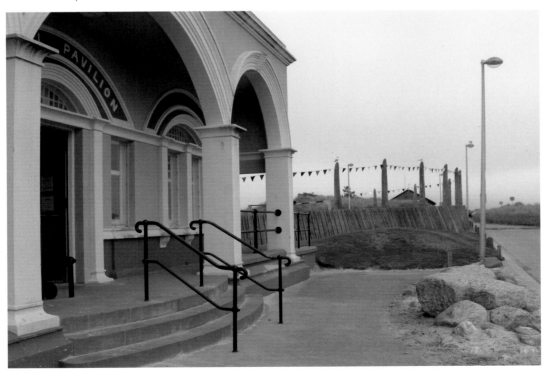

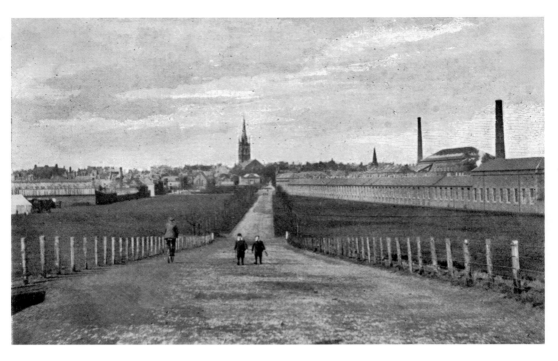

Trail Drive
Montrose from the Links Railway Bridge, at the start of the Trail Drive. The church steeple can be seen in the background. Paton's mill, on the right, has nearly all been replaced with new housing.

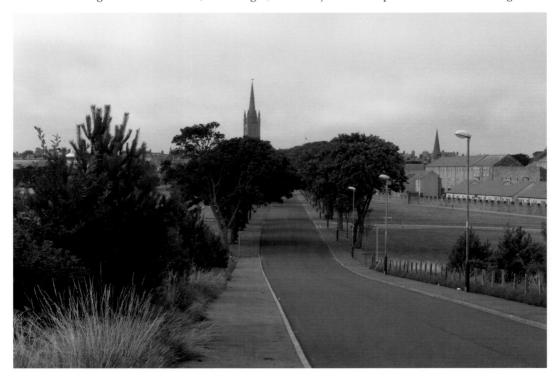

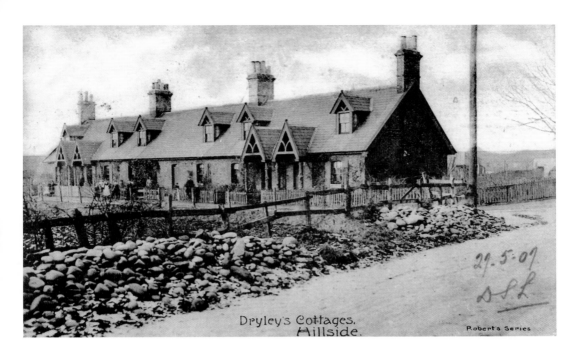

Dryley's Cottages.
Hillside.

Roberts Series

Dryley's Cottages

Apart from a few minor alterations to the front doors, little has changed here at Dryley's Cottages, which can be found on the left of the main road before entering the village of Hillside.

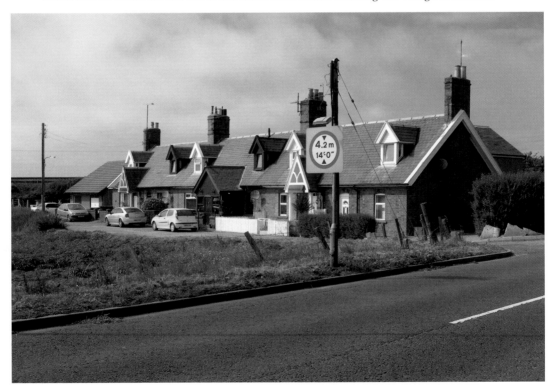

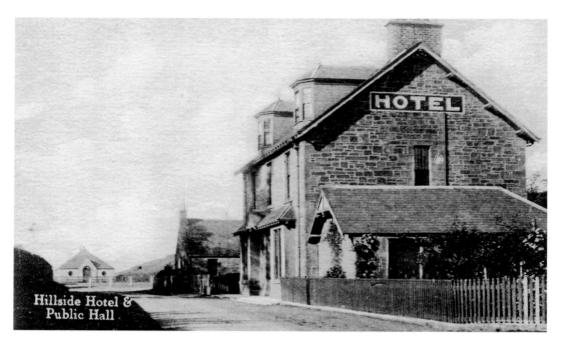

The Hillside Hotel

The Hillside Hotel is situated on Kinnaber Road. This is the only hotel in the village and there is very little change here, apart from the extra window between the dormers on the roof.

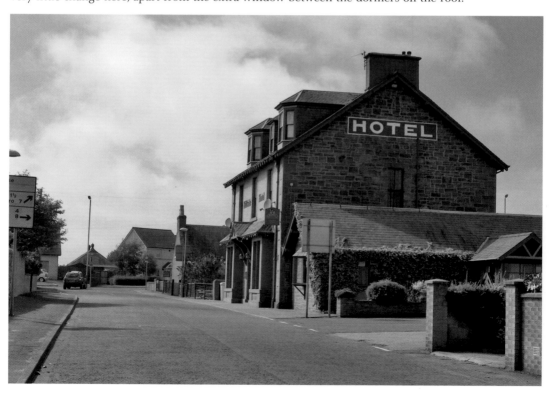

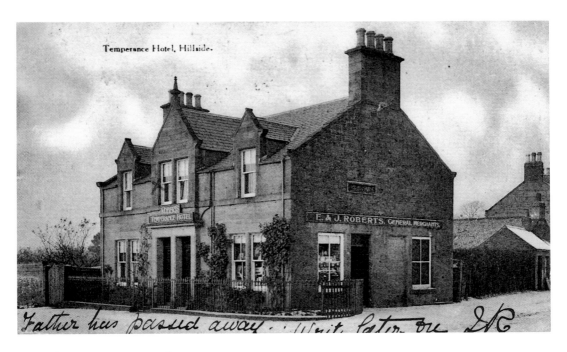

Temperance Hotel, Hillside.

Father has passed away. Write later on SK

The Temperance Hotel

The Temperance Hotel, at the bottom of the main road in Hillside, is now a private residence, and the shop on the end is now away. A garage has also been built to the left of the building.

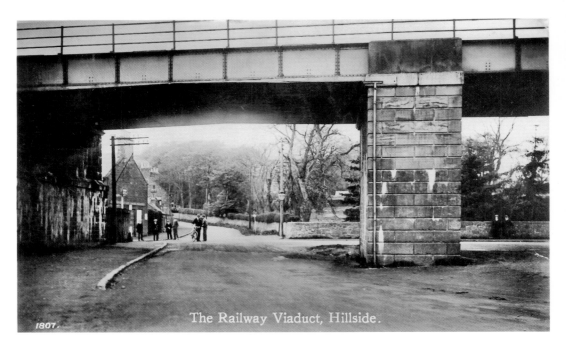

The Railway Viaduct, Hillside.

1807.

Hillside Viaduct

The railway viaduct at Hillside, which carried the railway line from Dubton to Hillside station. Both stations are long closed and the viaduct was removed in 1986.

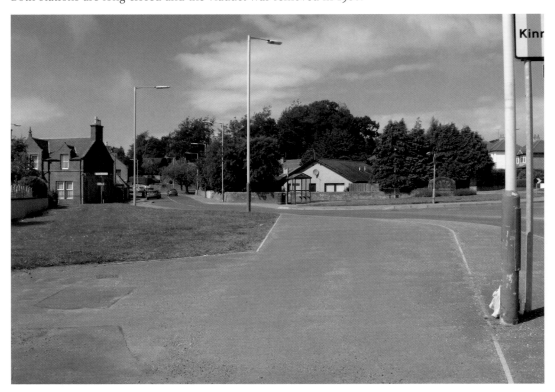

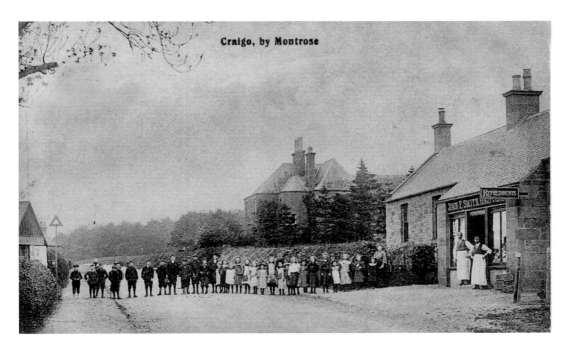

Craigo, by Montrose

Craigo Post Office

This building is on the Hillside to Marykirk road, and once served as the post office and shop for the Craigo area until its closure in 1984. It is now a private residence. Only the wall box remains from when the post office was there.

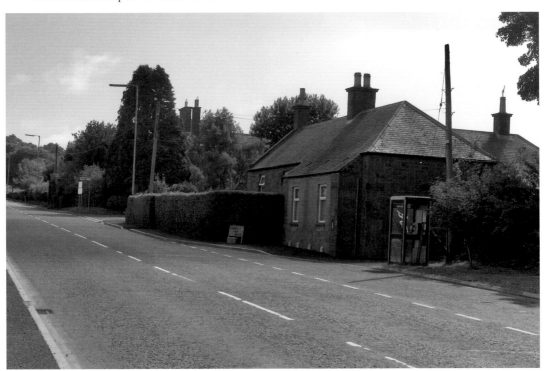

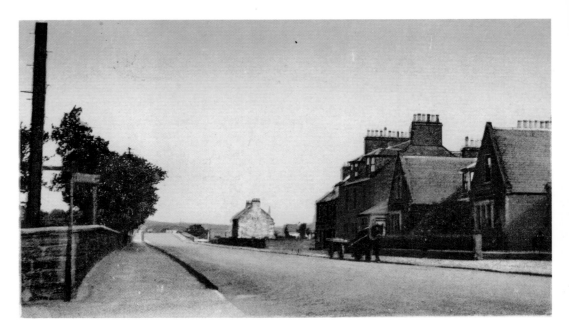

Northesk Road
Northesk Road looking north, towards the Victoria Bridge. There has been little change to the buildings on the right, but a garage has been built further along from them. Gone now are the common sites of the horse and cart.

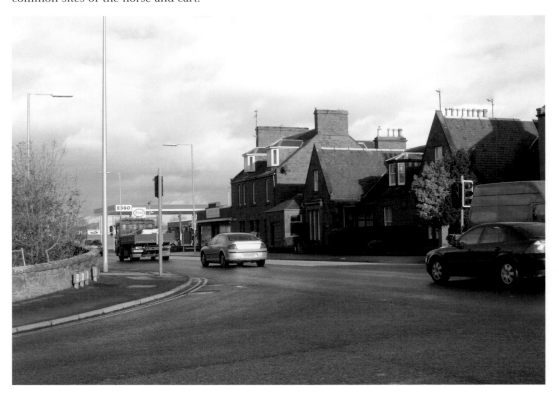

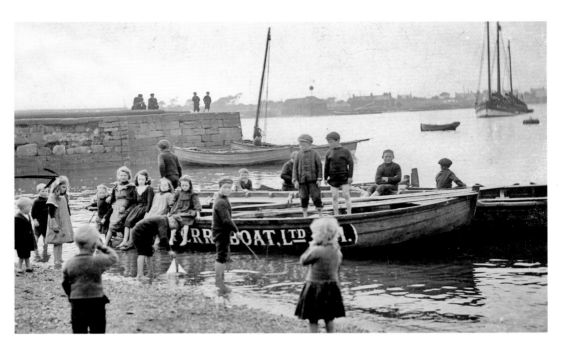

Ferryden Beach
Children playing on the ferryboat at Ferryden beach in the early 1900s. This pier was extended when the Sea Oil base was built in the 1970s.

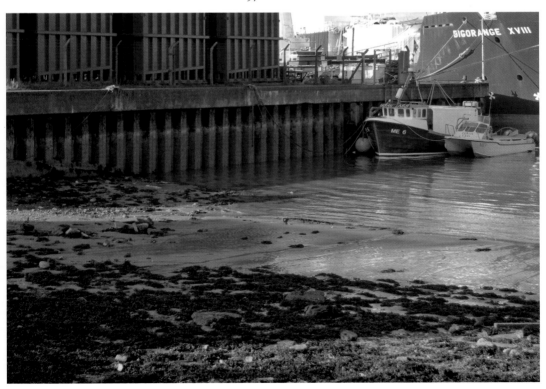

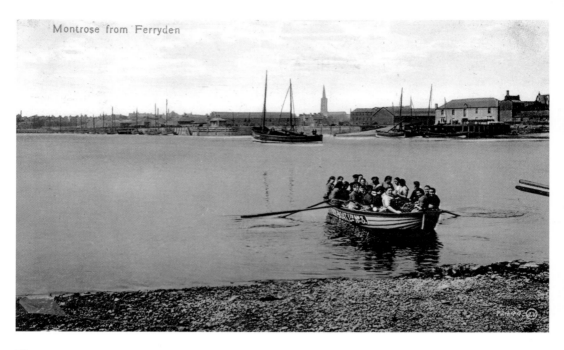

Montrose from Ferryden

The Ferry

The ferryboat landing at Ferryden beach. Most of the young girls of Ferryden used this means of transport to get to Montrose to work at the mill. The Montrose harbour is now a busy port, with cargo ships and oil support vessels regularly entering and departing on both sides of the river.

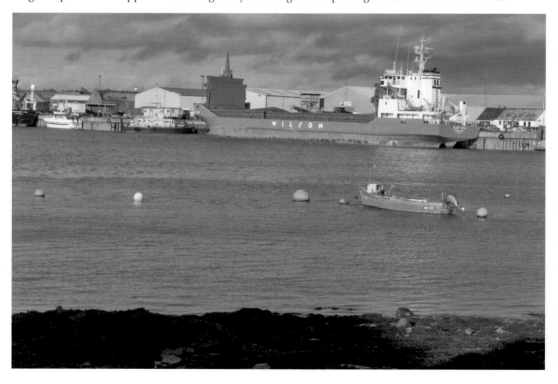